HARBORNE
THROUGH TIME
Beryl Beavis

AMBERLEY PUBLISHING

This book is dedicated to the memory of members of my family,
the Parkers, the Neweys, the Apperlys, the Rowleys and my late husband Tim,
and also my children – Mark, Adrian and Rachel – who have all helped
to make Harborne what it is today.

Front cover:
The Moor Pool
In days gone by this pool supplied water for the washer women of Harborne or was the swimming pool for the local lads. Today it is an oasis of calm and home of the Moor Pool Fishing Club.

First published 2011

Amberley Publishing
The Hill, Stroud
Gloucestershire, GL5 4EP

www.amberley-books.com

Copyright © Beryl Beavis, 2011

The right of Beryl Beavis to be identified as the Author of this work has been asserted in accordance with the Copyrights, Designs and Patents Act 1988.

ISBN 978 1 4456 0559 3

British Library Cataloguing in Publication Data.
A catalogue record for this book is available from the British Library.

Typeset in 9.5pt on 12pt Celeste.
Typesetting by Amberley Publishing.
Printed in the UK.

Introduction

Much of Harborne has changed beyond recognition, from what was mainly a farming community in 1850 to an outer suburb of Birmingham. Most of the buildings were erected between 1850 and 1900, with a great deal of rebuilding particularly during the latter part of the twentieth century. The railway, the fire station, and the Chad Valley Works have come and gone. The farms, the mill and the large houses are remembered in road names and housing estates. Change continues, but amongst it some of 'old Harborne' can still be found if you know where to look.

The ancient parish of Harborne, which included Smethwick, has records that go back many centuries. At the time of Domesday (1086), Harborne and Smethwick existed as two separate manors – Smethwick being about twice the size of Harborne – but at some point they were amalgamated and in the thirteenth century the Abbot of Halesowen was the Lord of the Manor. The parish became divided as the manorial lands were sold. A major split occurred in 1709 when Philip Foley sold the manor of Harborne and Smethwick. The southern part, Harborne, was bought by Thomas Birch, and the northern, Smethwick, by Henry Hinkley. Both were part of the diocese of Lichfield, and in the county of Stafford. The modern A456 marks the boundary.

At the beginning of the nineteenth century, Harborne and Smethwick were very similar, largely farming communities, but already there was evidence that they were developing differently. In Smethwick, the Birmingham to Wolverhampton canal had been opened and major industries were being built along the canal side. Further industrialization took place with the building of the railway. Although there was some industry in Harborne, it remained largely rural until the latter half of the nineteenth century, protected in many ways by the Gough-Calthorpes of Edgbaston who wanted no industry or retail premises on their land. Eventually, Smethwick took the decision to remain in Staffordshire while Harborne joined with Birmingham in 1891.

The Harborne tithe map of 1840 shows that there were three main centres of population: one near the church with its pub, the Bell, the vicarage, the new Manor House and several smaller dwellings; one at the junction of Park Lane (now Harborne Park Road) and Lord's Wood Road, with at least two public houses, the King's Arms and the Duke of

York, and Newey's timber yard; the third at Harborne Heath, the 'waste' of the Manor, just on the boundary with Edgbaston where the hill goes down to the brook. There were at least two public houses, the Green Man on Heath Road, (now the beginning of Harborne High Street) and the Fish Inn, in Fish Lane (now North Road). So this was not a typical village. It was at this end of the village that house building proceeded rapidly with rows of terraced houses, while generally the larger houses were built along Greenfield Road, Wentworth Road, Lordwood Road and Harborne Park Road. These are where some of the well known names of Harborne lived, such as the Kenricks, the Chamberlains, David Cox, the artist. Other Harbornites include Thomas Attwood, Birmingham's first MP, Edward Capern the poet and Elihu Burritt, the US consul.

Our journey through Harborne will start from the Green Man along the High Street, turning right at Lordswood Road. A left turn along Croftdown road will take us towards the boundary with Quinton, and going anticlockwise until reaching the Golden Cross, which was once the boundary of Worcestershire, Warwickshire and Staffordshire. Sadly, the pub has just been demolished for the second time in its history.

From there our route will take us back through the village centre, venturing into the side roads and Moor Pool Estate, and finally reaching the original parish church of St Peter, which once served the whole of Harborne and Smethwick.

Acknowledgements

My thanks go to Harborne Library for use of the majority of the photographs donated over the years by various people from the Donald Wright collection; to the Librarians, but particularly to Wendy Carter for help in locating and scanning them; to Mike Morris for all the information about the buses, and the photograph of 'St John's Church'; to Ian Uden for 'the last train'; to Andrew Maxam ('Old Harborne Village Calendar www.maxamcards.co.uk') for the photographs of 'the Olde House at Home', 'the Avenue' and 'the Duke of York'; and to the local history group for helpful information.

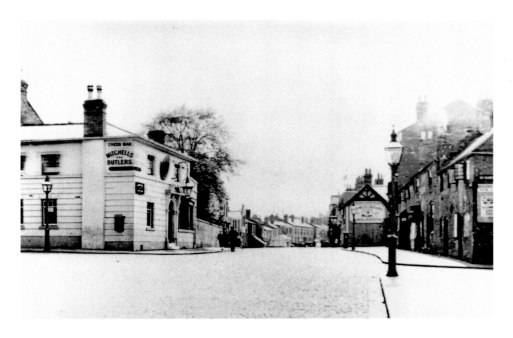

Approaching Harborne

This approach to Harborne from Birmingham city centre is up a steep hill. In the old days, passengers were sometimes asked to walk when horse-drawn buses found the road too difficult to climb with a full load. On the left is the Green Man. This area of Harborne was known as Harborne Heath. A brook flows at the bottom of the hill, an area that was often flooded or marshy. Ahead is the High Street.

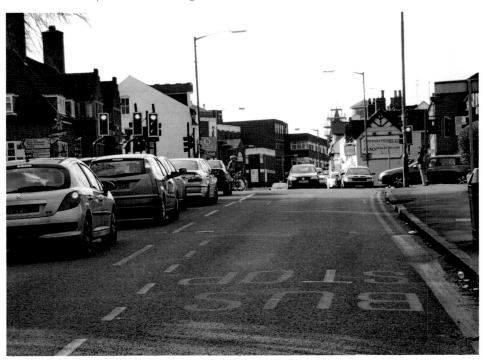

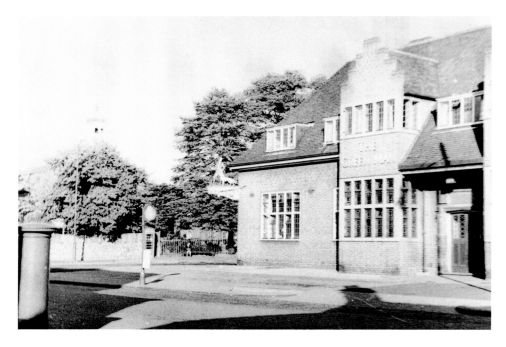

The Green Man

The original Green Man was demolished in 1938/39 and the present building erected soon after. Today it has a much more welcoming look with plants and tables. This was the 'home' of the Harborne gooseberry growers who won many prizes in competitions. It is now such a busy road junction that the bus stop has been moved further up the High Street.

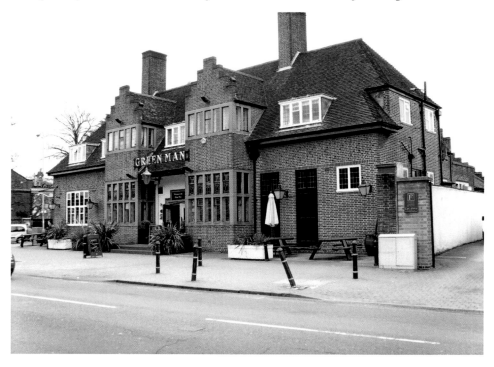

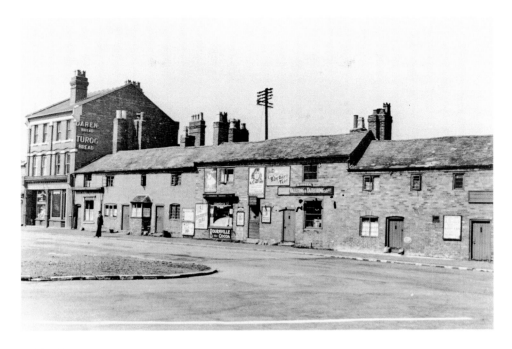

Nailers' Cottages.

Opposite the Green Man were the so-called 'nailers' cottages'. Nailing was the cottage industry of Harborne, but not one of the inhabitants in the 1851 census is a nailer. In those days this was Heath Road. These cottages, which survived until 1952, have been replaced with modern offices, although in the 1960s there was a bakery on this site.

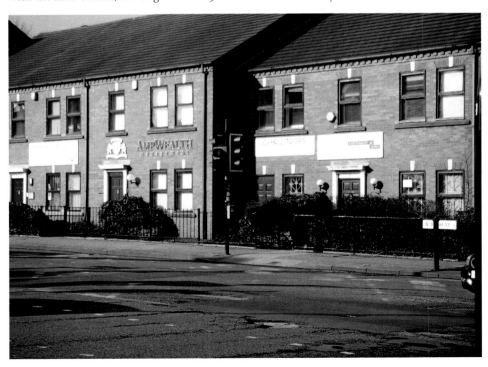

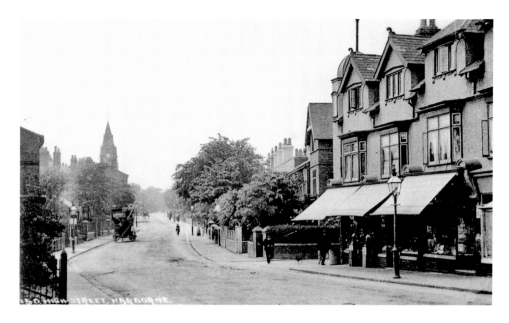

Harborne Heath

If we had walked along this end of the High Street about 100 years ago we would have seen many more houses and trees than can be seen today. Most of these houses were demolished to make way for the modern shops. Some have living accommodation above them and on the left is Lingfield Court, providing sheltered accommodation.

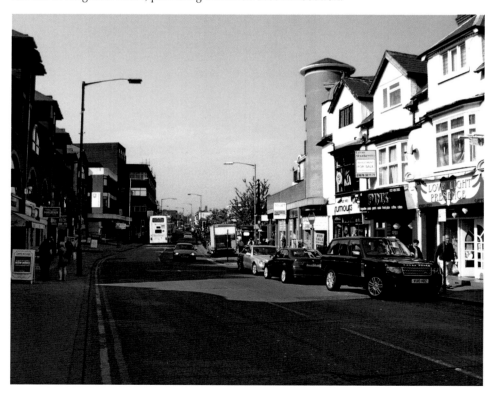

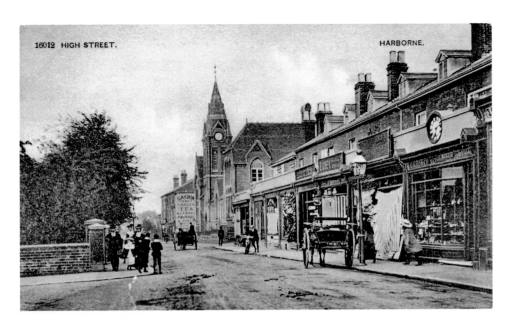

The Clock Tower

How times change. There is no evidence of cars in this view of the High Street – taken in 1904 looking back towards the city – only horse-drawn vehicles and a bicycle. The tall building, now known as the 'Clock Tower', was built by the Harborne and Smethwick School Board in 1881, possibly on the site of an earlier Methodist School where, in 1851, David Wrapp was the Schoolmaster.

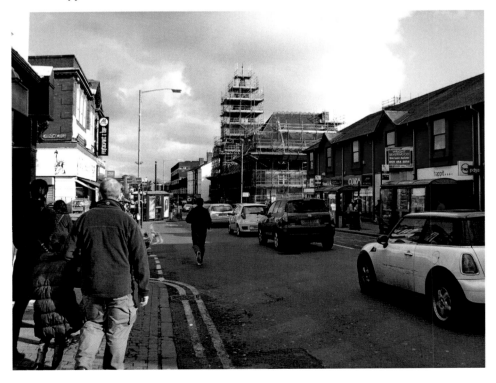

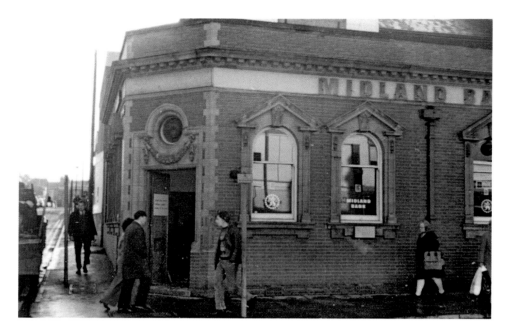

New Housing

When rapid house building began in the middle of the nineteenth century, three roads of terraced houses were built on land belonging to Josiah Bull York. They were named York Street, Bull Street, and Josiah Street. The latter was changed to Greenfield Street and later still to South Street. The Midland Bank, once a lovely terracotta building, is on the corner of Bull Street, now HSBC.

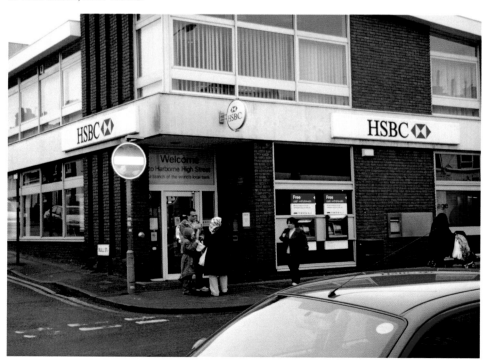

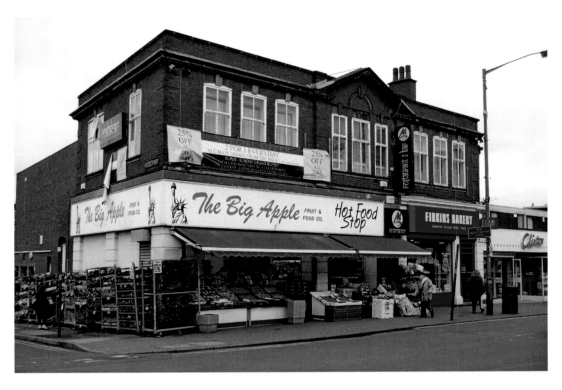

Big Apple!

Not all of this part of Harborne has been demolished, although it has changed its use. The old post office has moved into new buildings just beyond in a new parade of shops. The furniture shop has become a greengrocer.

The Methodist and Catholic Beginnings

This original Methodist church, in use by 1851, had two small cottages on either side. As the congregation grew, a new one was built in South Street, opening in 1868. In 1870, these redundant premises were bought for use by the Catholic Church. In 1877, they too were able to build a new church in what was then known as Lodge Road, although their school remained here until 1895.

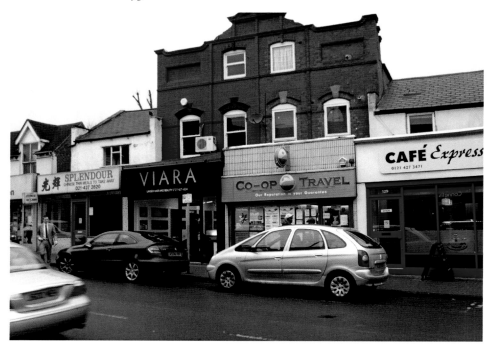

A Listed Building

The new Methodist church, now a Grade II listed building, was built towards the top of the hill in South Street, just up from the High Street and almost opposite its original site. The Methodists no longer use the building as there were problems with the cost of all the renovations needed to turn the rear hall into a community room. Because of the increase in traffic and the problems caused by parking it is now a one way street. Although many of the houses are old they have been renovated and are much sought after.

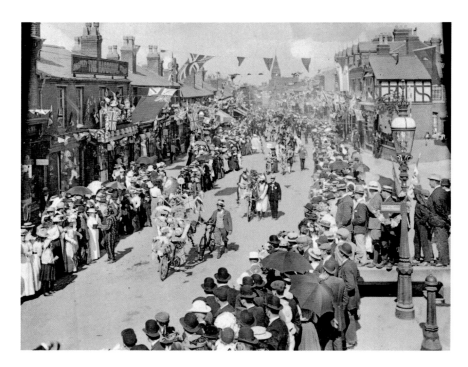

The Vibrant Village

1911 saw the coronation of King George V – a cause for a celebration parade. Gone now are the gas lamps and the horse trough that once stood on the island outside the Junction Inn. Many of the shops that were once part of a typical village high street; the fishmonger, the grocer and the haberdashers no longer exist here in Harborne. There is now a plethora of banks, building societies, estate agents, travel agents and charity shops.

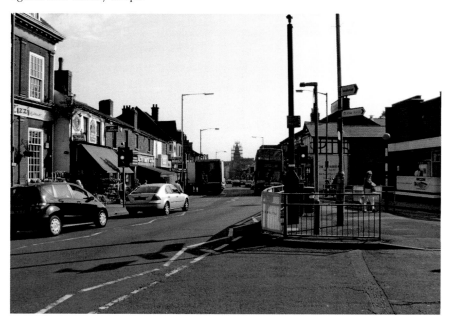

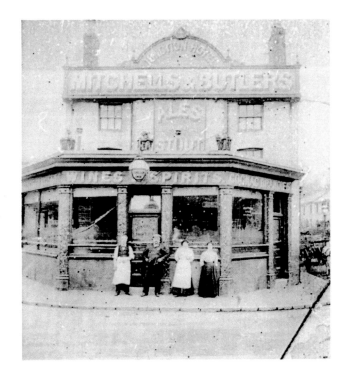

The Junction

The 1840 tithe map shows us that this site was occupied by Michael Parker, a nailer. In 1841 he was living there with his wife Theresa and seven children. An eighth child was born in 1844. Unfortunately, Michael died of a diseased throat and, in 1851, Theresa – now described as a Pauper and laundress – is living with the five youngest children, (three of whom have jobs), in the almshouses further up the High Street. Ann – described initially as a 'beer retailer' – and Levi Monk acquired the premises and it became a pub. Tom Presterne describes it, 'The Junction Inn was an old-fashioned whitewashed house with a tiled roof and a garden in front extending to an acute point between High St and Lodge (Vivian) Rd, with a long wooden water trough in front.' The modern pub (below) was opened in 1903 so the Junction Hotel (above) was probably built early in the latter half of the nineteenth century. In recent years it became O'Neill's but has now reverted to the Junction.

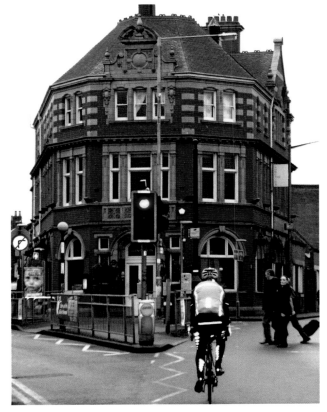

The Library

The library was once a Masonic Hall. The library steps (by the mini) no longer exist, as a shop was incorporated and a lift installed. Most noticeable in these pictures is the change from a pedestrian crossing to traffic lights. Not so obvious is that Vivian Road (to the left) is now a one-way street. Shaws the chemist, on the corner of Albany Road, became an estate agents. Zizzi's was Lloyds bank but they moved into new premises becoming Lloyds TSB.

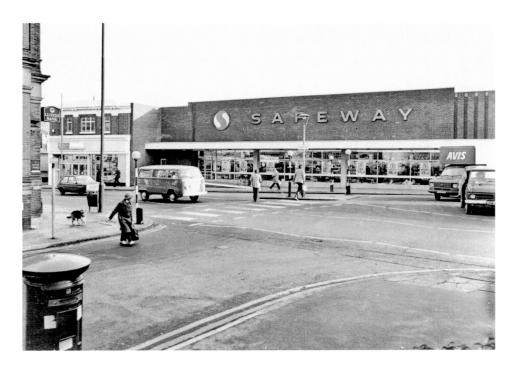

Supermarkets

The old photograph (1980) again shows the pedestrian crossing with its flashing Belisha beacons. Cars can be seen turning out of Vivian Road; something which became harder to achieve as the traffic increased, especially a right turn. Lloyds bank is on the left of the picture. Across the road are Safeway and Woolworths, which disappeared from Harborne High Street many years ago. Safeway had replaced other shops and businesses before being bought by Morrison and then Waitrose.

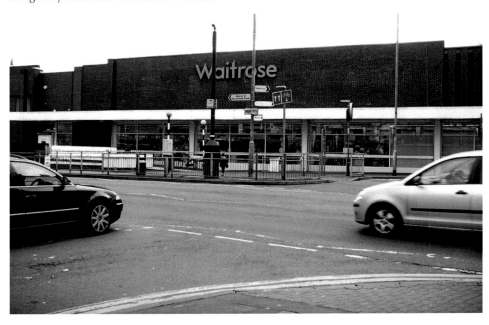

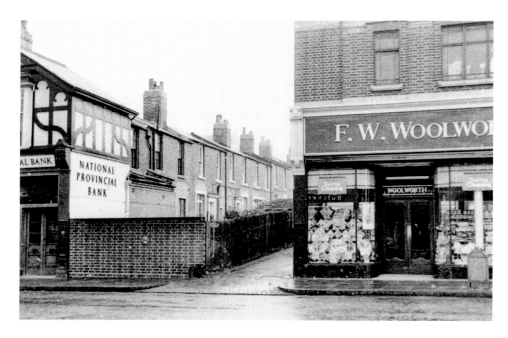

Disappearing Harborne

Between Woolworths and the National Provincial Bank – now a jeweller's – was a row of terraced houses. There were several of these terraces in Harborne but most have been demolished and new homes built in their place. The buildings to the left of the jeweller's have had their top storey removed (*see coronation picture*). The land is now used as a car park but it is now possible to see the rear of Methodist Church.

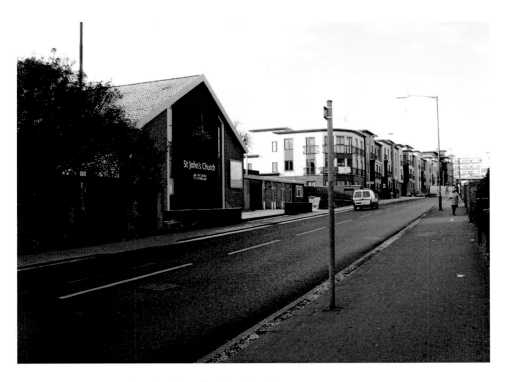

St John the Baptist Church (Church of England)

This was the site of St John's Infant and Mixed School from 1866 until 1917. In 1921, a new frontage was added as a war memorial to remember the dead of the First World War. Later those from the Second World War were added. Today these names can be seen just inside the door. The new church, replacing the one in St John's Road, opened in January 1960 but the main front door was blocked up in the 1970s to create more seating inside.

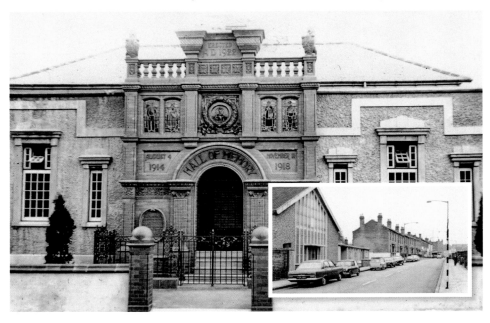

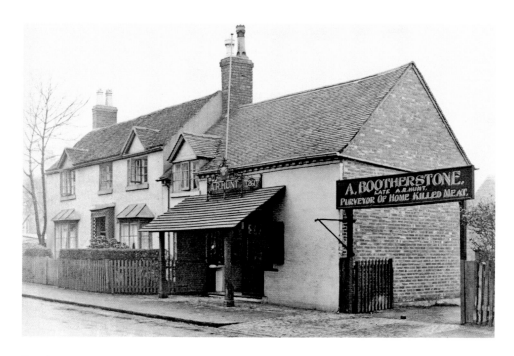

Bootherstones
Today it is a petrol station filling ever-hungry cars; it had been a butcher's for more than 100 years before it was demolished in the middle of the twentieth century. Between the library and the petrol station there is a row of terraced houses. Those nearer the library, sometimes referred to as Matchcroft, are the oldest and part of a row that at one time went right across Albany Road.

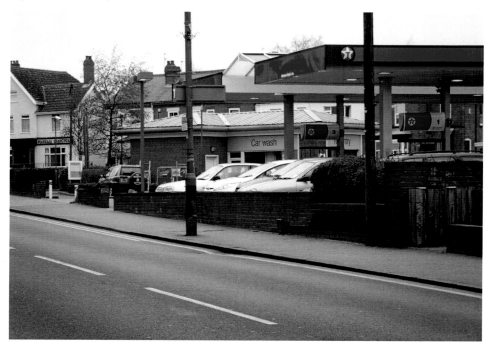

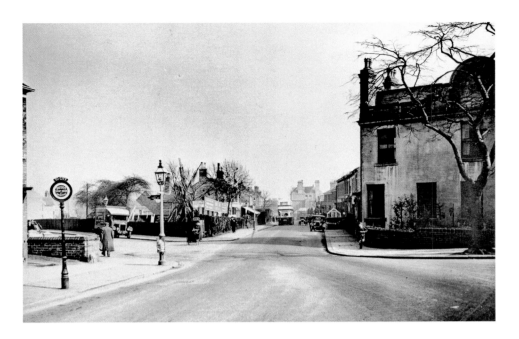

The 'New Road'

Looking back down the High Street from the corner of Greenfield Road many changes can be seen. This part of Harborne is referred to in eighteenth century documents as 'the road leading to Matchcroft', little more than a track. Bootherstones has become the petrol station, the gas lamps have been replaced by electric, the bus stop has moved, the block of apartments has replaced the all electric garage – which itself replaced the police station – and the Junction Inn has shortened a chimney.

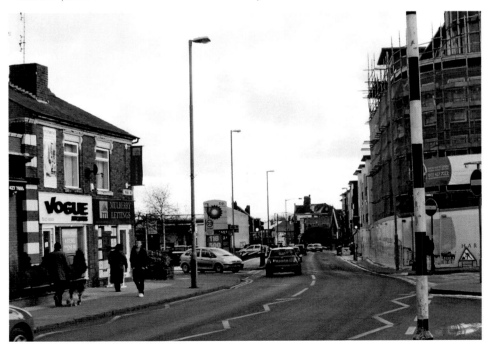

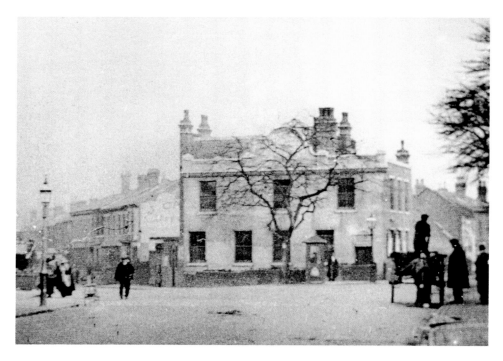

The Old Police Station

The picture below shows the police station just before it was demolished to make way for an 'All Electric Garage'. The above picture is much older and shows how it may have looked when it was a school. Behind the school were the original almshouses, which were demolished in 1913. There were eight of them: four for single people and four for families. Note the old-style telephone box, the decoration on the front of the house and the chimney pots.

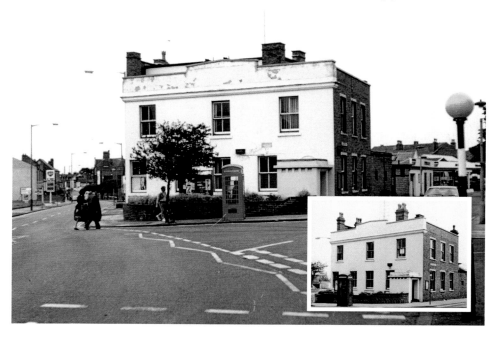

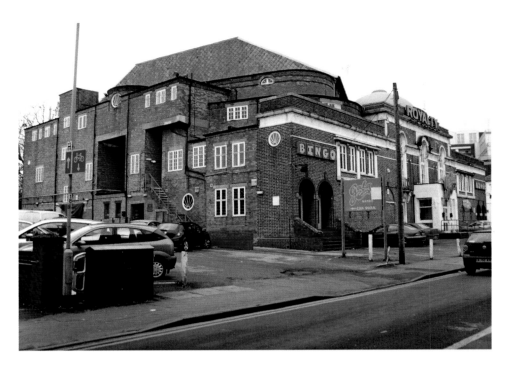

A Grave Situation

Loxley was a stonemason for headstones and monuments, moving here in 1899 to a site previously occupied by Thomas Hill, another Stonemason. In 1930 the building was demolished along with the row of terraced houses behind it to build the Royalty Cinema. The cinema long ago stopped showing films and is now a Bingo Hall. During the war, public air raid shelters occupied the car park.

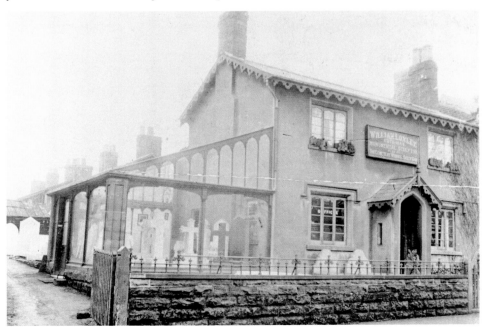

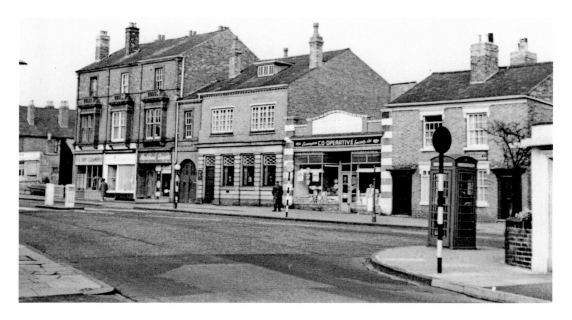

Co-operation

Opposite the Royalty in 1964 were the Birmingham Municipal Bank and a branch of the Birmingham Co-operative Society. The Co-op moved into new premises across the road as a supermarket, but that has now gone; the bank became the TSB and later Lloyds TSB. The two buildings are now Henry Wong's Chinese restaurant. Due to road alterations the phone box has also been moved.

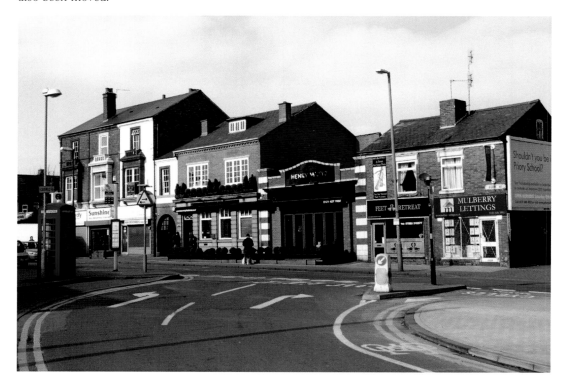

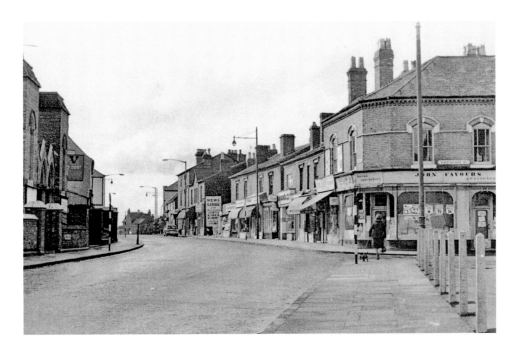

Pinner Court

On the right is Ravenhurst Road and to the left can just be seen the Baptist church, minus its original spires. In the row of houses and shops on the right was the original police station with the cells behind, and round the corner was the pass house. In the far distance can be seen the chimney of the swimming baths. The new building is Pinner Court – sheltered accommodation.

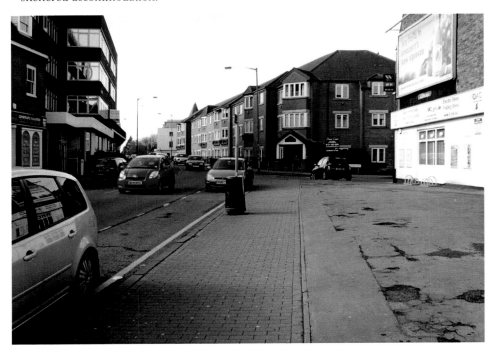

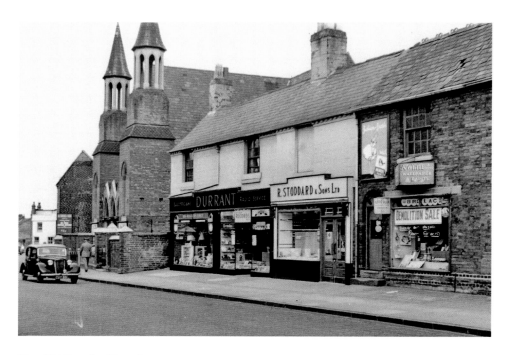

The Old Baptist Church

These photographs are of the same stretch of the High Street looking in opposite directions. The Baptist church, along with the row of shops and houses, was demolished around 1958 (note the demolition sale notice) to make way for this office block with shops underneath. The church was built in 1864 on the site of an old chapel that had been used by both the Congregationalists and the Baptists. The Baptists originally met in Harborne Heath.

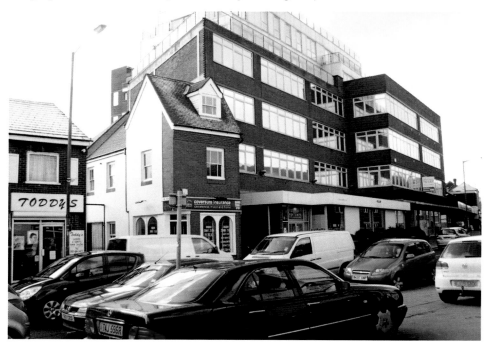

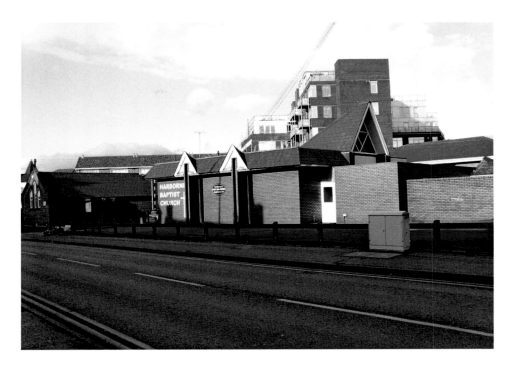

The New Baptist Church

The new Baptist church was built behind its original site with the front facing on to Harborne Park Road. The top photograph shows it as it was first built (the office block on the High Street can seen behind it). Very recently the church has been extended and given a completely new glass frontage and a ramped entrance.

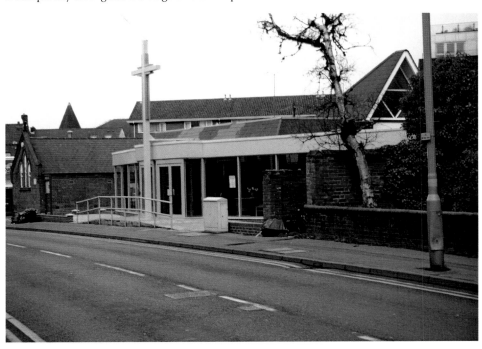

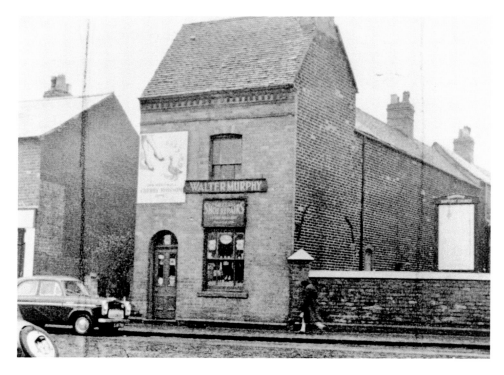

Murphy's Row

Next to the Baptist church was Walter Murphy's shop and behind that was Vine Terrace, a row of houses built in the 1820s. Many were occupied by nail-makers, with workshops at the rear. It was often referred to as 'Murphy's Row'. For many years this was G. Kalton's photographic shop, but the whole row was pulled down and the end shop was built as a replica.

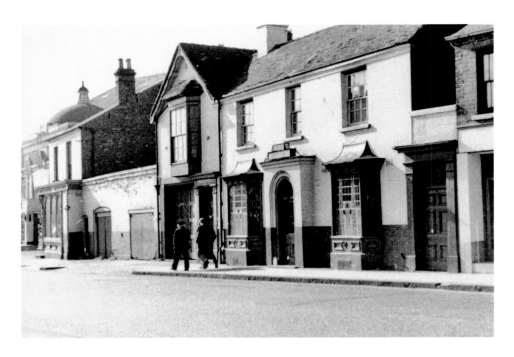

The Vine Inn

The original Vine Inn was built in the 1830s. This was just one of the pubs, around a dozen that formed what was known as the 'Harborne Run' – a drink in each from the White Swan, technically in Edgbaston, along the High Street, plus a few side streets, to the Duke of York. If you had the stamina there was the Scarlet Pimpernel at the bottom of War Lane or the Kings Head along the Lordswood Road.

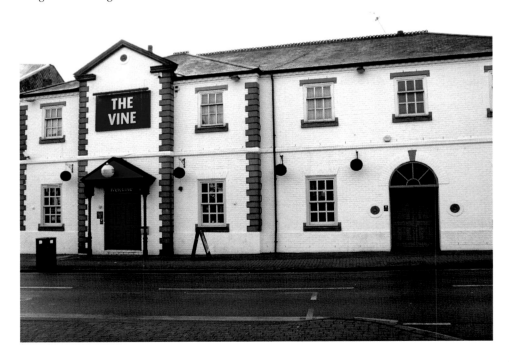

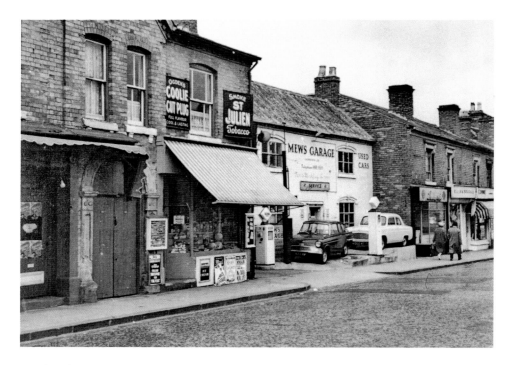

Harrison's Farm

The Mews garage was once a farmhouse belonging, in 1841, to Mary Harrison. The farm, sometimes called Pinner's farm (hence Pinner Court), extended as far as the Harborne Styles footpath (*see page 66*). Her grandson, James Newey, took over the farm before it was eventually sold and houses built. James, his wife Agnes and their children then moved to Church Farm, near St Peter's Church.

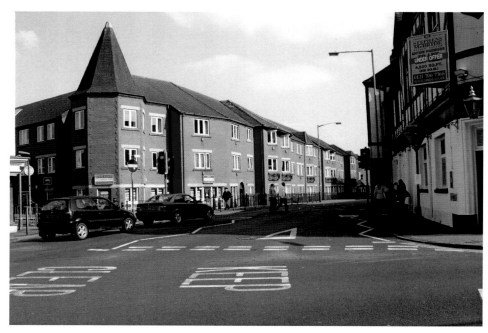

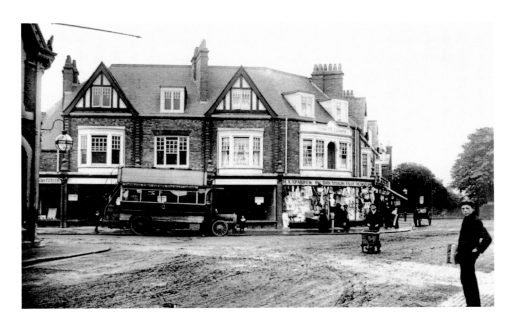

Prince's Corner

This photograph of Prince's Corner, built around 1903, was taken in 1915. The bus is Tilling Stevens, TTA2 40 hp petrol-electric bus, with Brush body work, seating eighteen upstairs and sixteen down, with an open top. It is waiting to pick up passengers outside Harborne Terrace. Here, once the village green, stood the Round House lock up, built by Thomas Green. Today it is a very busy road junction at the end of the High Street.

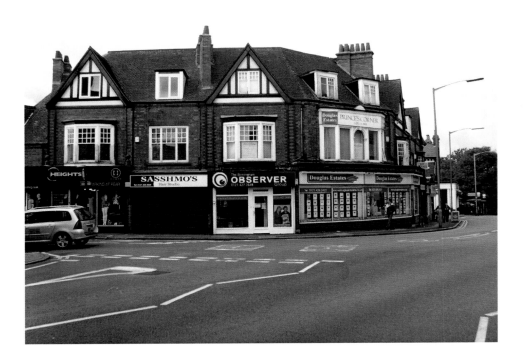

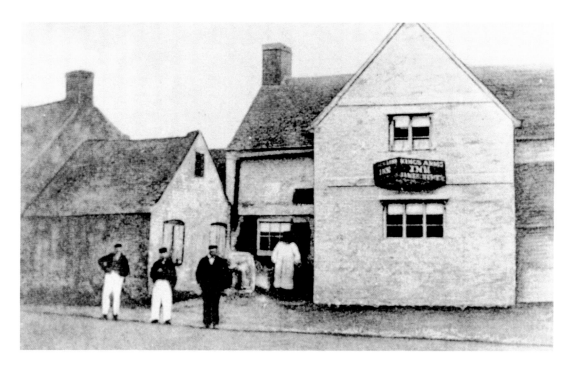

King's Arms Inn

The lower picture gives a good view of what is called 'Ye Olde Kings Arms' except that it was relatively new. The old King's Arms Inn (above) stood on this same site for many years way back in the eighteenth century. The same family were landlords for much of the nineteenth century – John Newey, his son James (not the farmer), and then James' brother Samuel. It was the scene of lavish parties but also the meeting place of friendly societies.

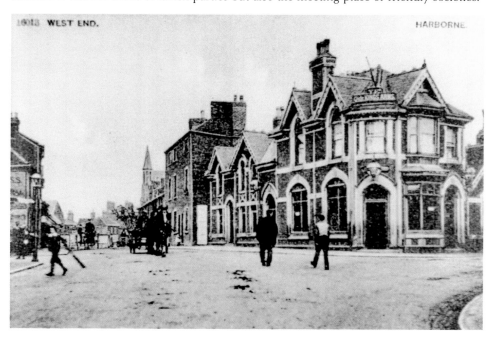

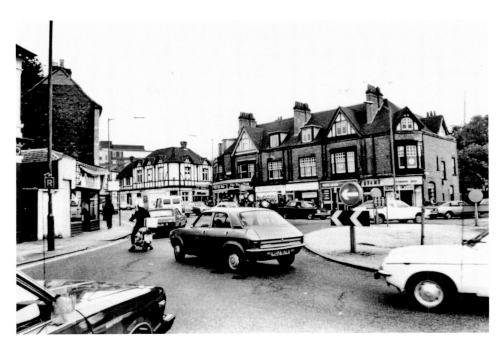

Looking down the High Street from Lordswood Road
Towards the middle of each picture can be seen yet another version of the King's Arms. In the lower picture it has acquired a coat of arms above the door. The buildings on the left have been completely demolished and two blocks of apartments have been built. The roundabout used to be known as the Duke of York island, but the pub has now gone. The traffic is unusually quiet in the lower picture.

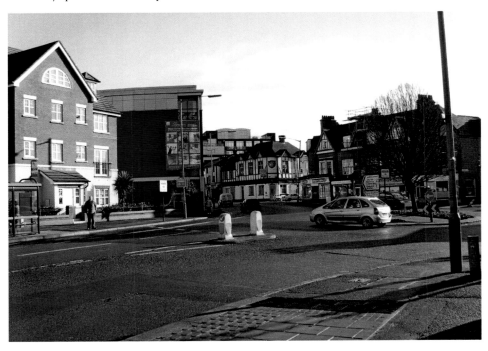

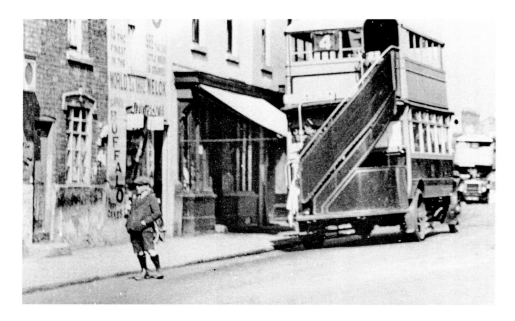

Harborne Terrace

Harborne Terrace was the terminus for the No. 4 bus, which ran to New Street in the city centre. It is an AEC504 6.8-litre petrol engine. Seating twenty-six both upstairs and downstairs it was originally open-topped, but Birmingham buses got their covers thirteen months before the London General Omnibus Co. The buildings have been replaced but there is still a bus stop and shelter with electronic timetables for the twenty-first-century buses.

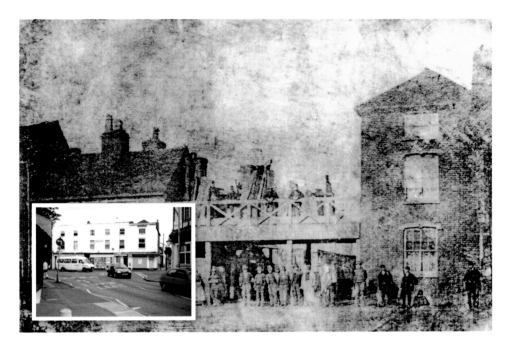

Newey's Timber Yard

Samuel Newey had a wood yard here that was passed down to his son John and then his grandson. Samuel lived in the house on the right, built around 1790, with a row of terraced houses in the yard. In early Victorian times, the block was filled in to form Harborne Terrace and the wood yard was accessed from Serpentine Road. The new facia is a replica. On the right is the Kings Arms pub, to the left Albert Walk.

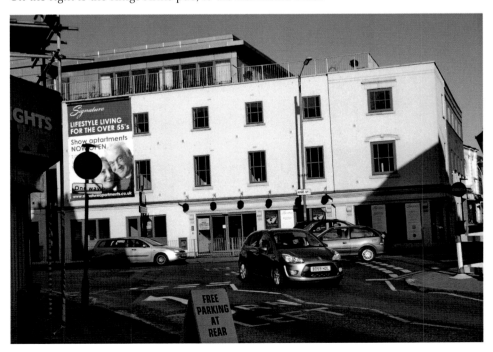

Frankley Terrace

This is one of the areas of Harborne in which some of the earliest buildings once stood. On the right is part of Harborne Terrace, now demolished, and in the distance can be seen Frankley Terrace, at right angles to Lordswood Road. Lordswood Road leads to Smethwick and is part of the Outer Circle No. 11 bus route. The larger house has been demolished but the terrace remains.

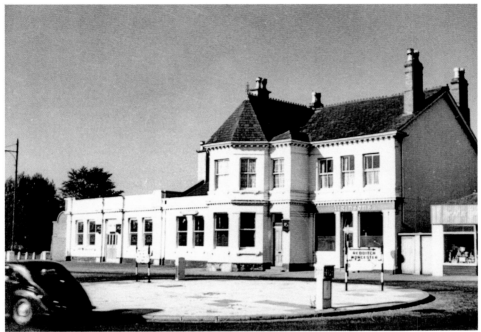

Duke of York

The Duke of York pub occupied this site for many years, but probably not as seen here. In the 1870s a row of old cottages behind the pub was accessed through the gap on the left, subsequently used as a car park. The pub was demolished in 2003 and the Lords apartment block erected.

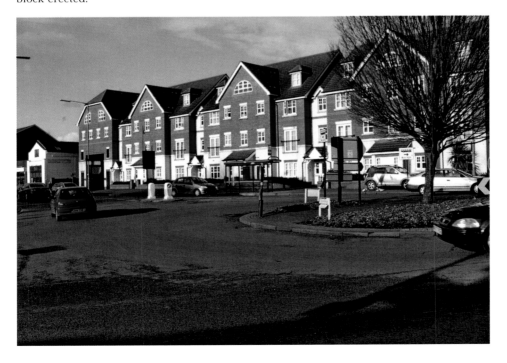

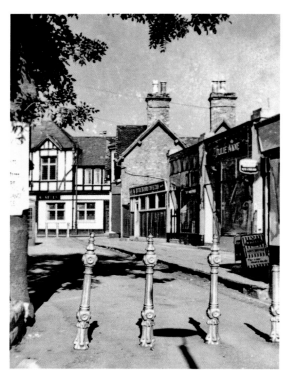

Albert Walk

At the end of Albert Walk (named after Prince Albert) are the King's Arms and Harborne Park Road. This was the start of a footpath to St Peter's church before Albert Road, Victoria Road and St Peter's Road, were cut. It was known as the 'Wedding Field's path'. The old house at the far end is still there, but all the properties with frontages on the left have been demolished. It was also known locally as 'the stumps'.

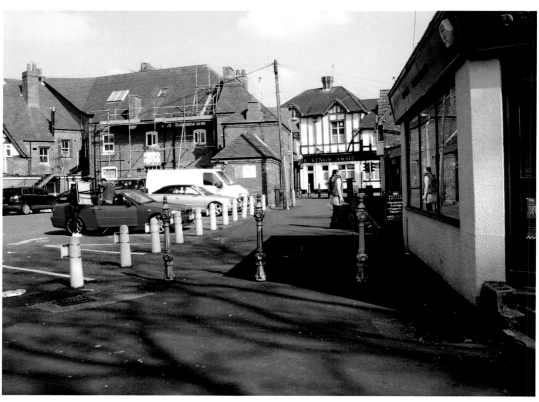

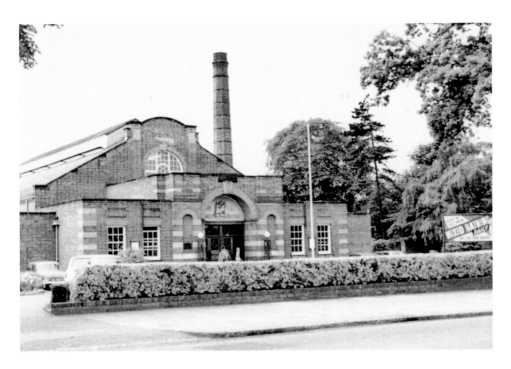

Harborne Swimming Baths

In 1910 a committee was formed, a bore hole was sunk, the war intervened and it wasn't until 1923 that the baths were officially opened. Even then it was only the private baths; the swimming bath was floored over and used for dances. A few years later the pool was in use. They have recently been demolished and a 'leisure centre' is replacing them.

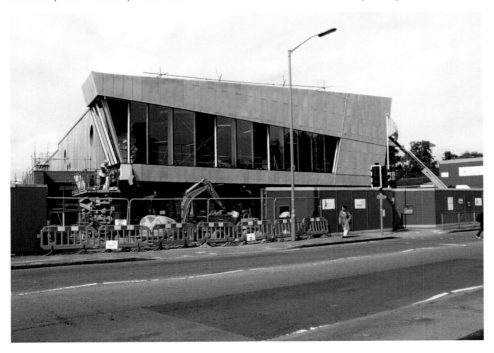

Bus Garage

In the 1920s there was new network of motor bus services and Harborne had the first purpose-built bus garage on the site of Newey's woodyard. It had a steel lattice roof so that there were no stanchions, giving the buses access to inspection pits and fuelling pumps. Upstairs were recreation rooms, a canteen, washrooms and a training school. It closed in 1986 and this housing complex – called Timbermill – was built.

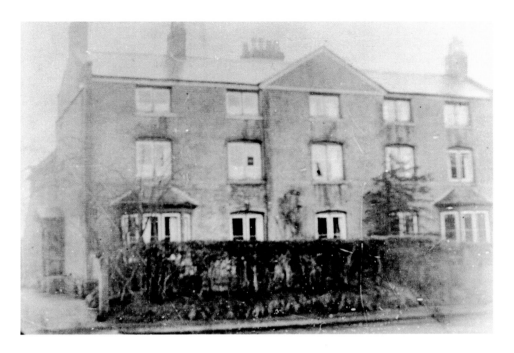

The Workhouse

The workhouse on Lordswood Road, near Gilhurst Road, was built so that it was around half way between the centre of Harborne and the beginning of Smethwick. In 1834, Harborne became part of the King's Norton Union, using the workhouse near the Green until a new one was built in Raddlebarn Road, Selly Oak. For some years the workhouse was used as a soap powder manufactory. The yew tree is the only remaining feature of this place.

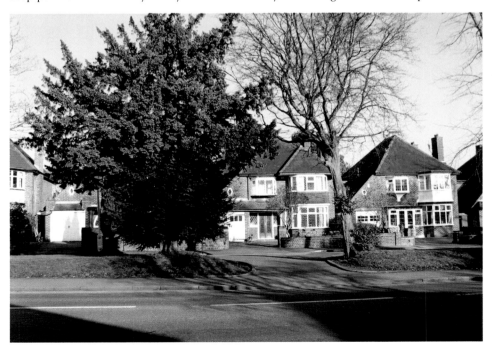

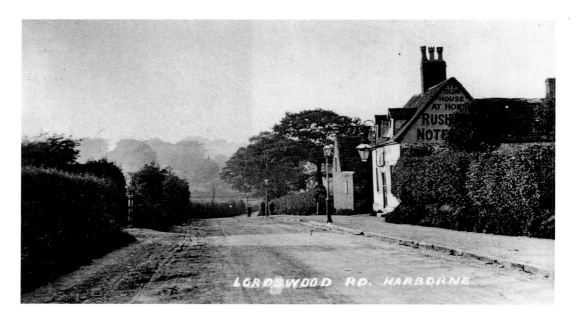

From Farm to Pub

Until the latter half of the nineteenth century this old 'Old House at Home' was a farm, worked by George Newey, brother of James at the King's Arms, who was recorded as being a potato dealer. In the modern photograph the house with the attic window has been confirmed as the site of this farm as pottery has been found in the garden and a cobbled yard was discovered when trying to double dig a vegetable plot.

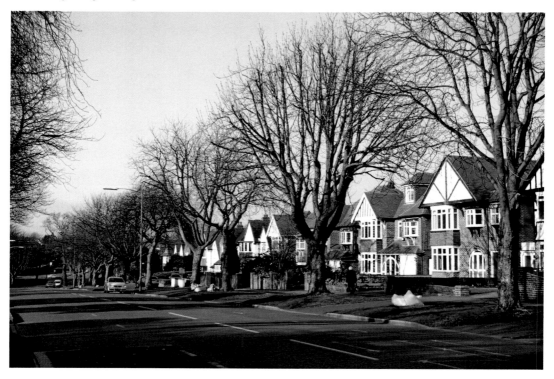

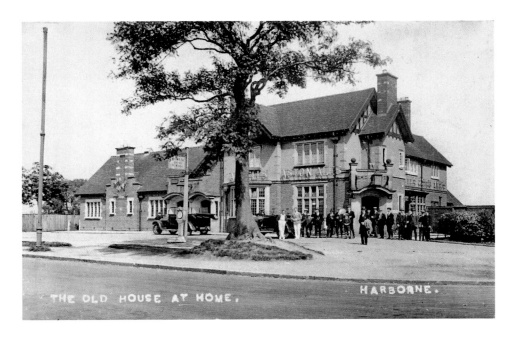

Old House at Home

The new 'Old House at Home' was built nearer to Harborne on the corner of Gilhurst Road, but it has undergone alterations, extensions and now has a Wacky Warehouse. The town planning map of 1926 shows that Gilhurst Lane was to be straightened out and continued on the other side of Lordswood Road as a wide road – Croftdown. Some of these planned roads were never completed because of the onset of the Second World War, and some were later re-sited.

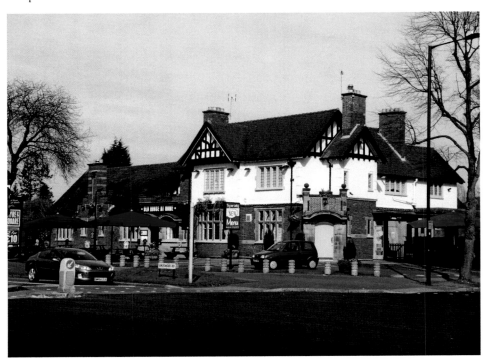

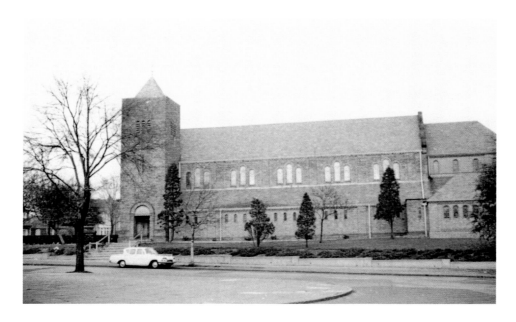

A New Church

As the population of Harborne grew, mission chapels were built to meet the spiritual and social needs of people some distance from the centre of Harborne. After many years and much discussion the site for a new church was chosen on the corner of Balden Road and Croftdown Road. It was begun before the Second World War, but only completed in the 1950s.

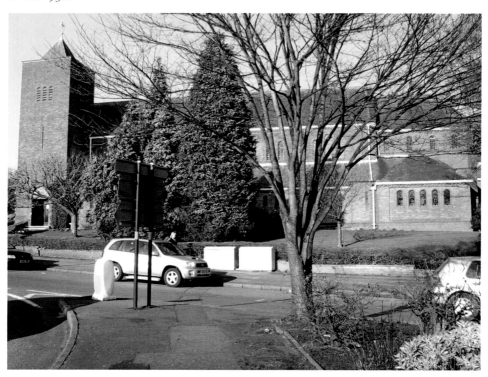

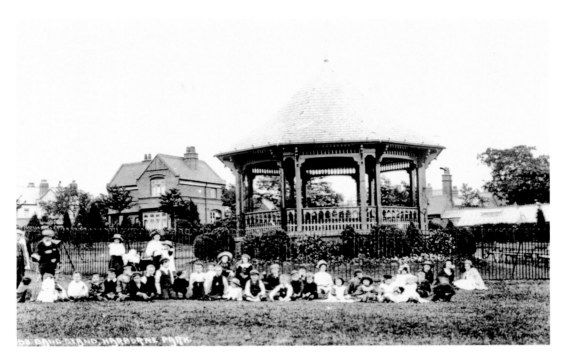

Queen's Park

Queen's Park was bought by public subscription and opened in 1898 to celebrate the Diamond Jubilee of Queen Victoria. The trees now almost obscure the house, the bandstand has gone, the railings removed, the access road re-sited and a car park built. It is still popular and has a children's playground.

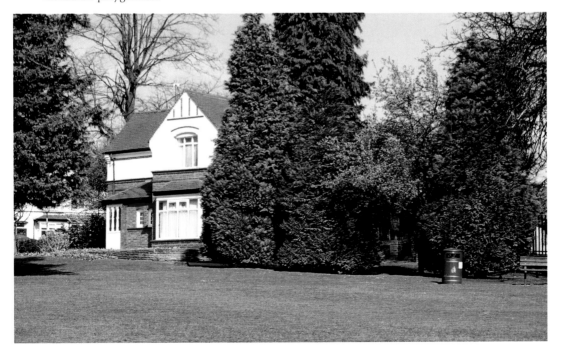

Tudor England

This beautiful Tudor house, Tennal Hall, was demolished in the 1930s to make way for a housing estate. It is possible that, during the Civil War, Queen Henrietta – wife of Charles I – stopped here for a rest on her journey from Walsall to King's Norton. At one time the hall was occupied by Job Freeth, an overseer of the poor, and later by Joseph Pearman, a farmer.

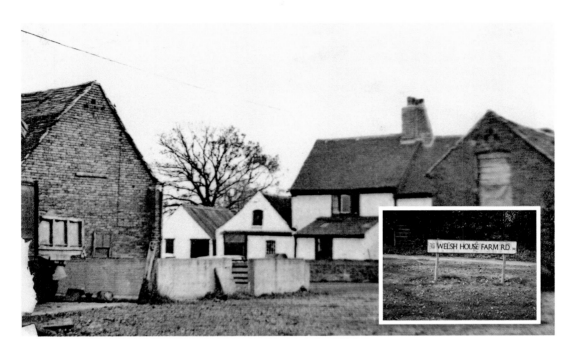

Welsh House Farm

This is another farm that has been demolished to make way for a housing estate. Access was from Tennal Road but the fordrough to this farm was from Northfield Road – roughly where Fredas Grove (lower picture) is today. The name lives on in what is known as 'the Welsh House Farm Estate'. At times it has been referred to as Welch House farm.

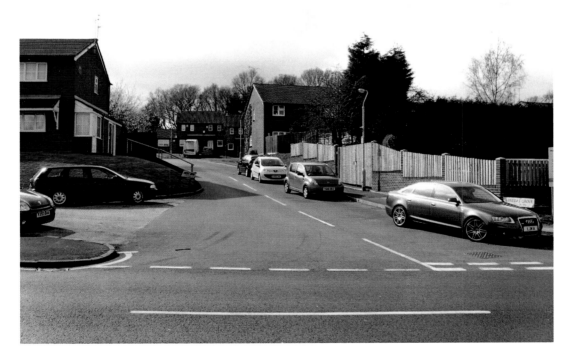

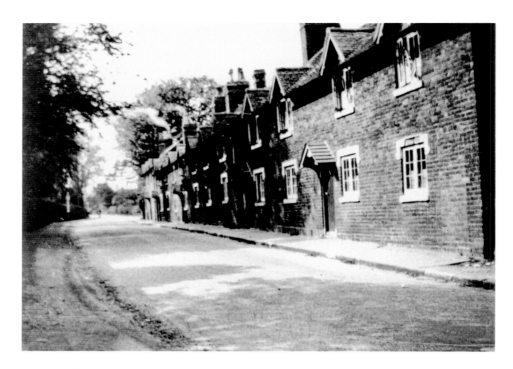

Cammomile Green

These are the nailer's cottages at Cammomile Green, Tennal Road, with workshops at the rear. The nailers would have had to walk into Birmingham each week to collect metal rods and then return with the handmade nails the following week. As the machine manufacture of nails increased, the cottage industry began to shrink, and it had almost died out by the second half of the nineteenth century.

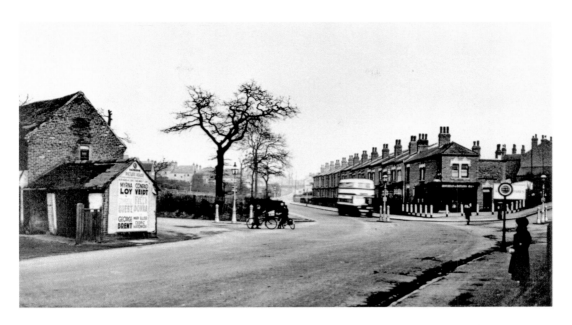

Hart's Green

A bus can be seen coming down War Lane from the Duke of York. To the left is Fellows Lane, an ancient 'holloway', and to the right are Vicarage and Victoria Roads. The farmhouse was demolished in 1934 and several decades later the layout of the roads was changed to cater for the ever increasing traffic – both cars and new bus routes.

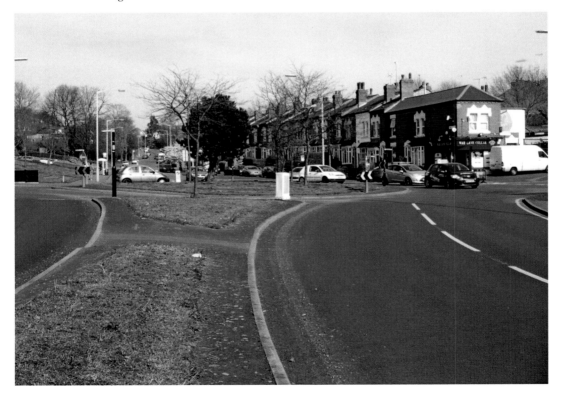

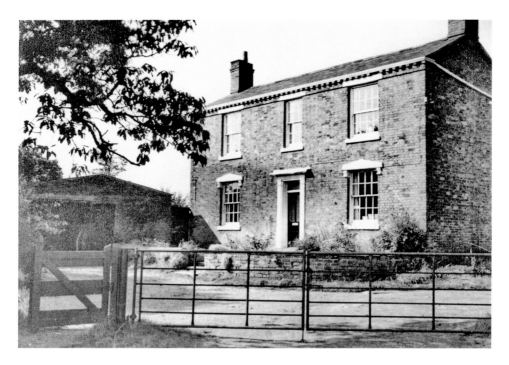

Home Farm

This building is one of the surviving farmhouses of Harborne, although it is no longer a farm. The land became part of Harborne Golf Course in the 1890s. It has subsequently been used to train police dogs and their handlers and is now a veterinary surgery. This access from Northfield Road is also used for deliveries to the golf course, although the clubhouse is in Tennal Road.

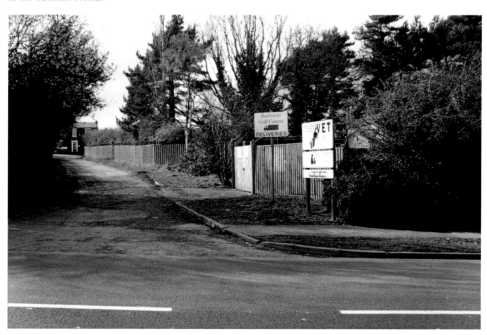

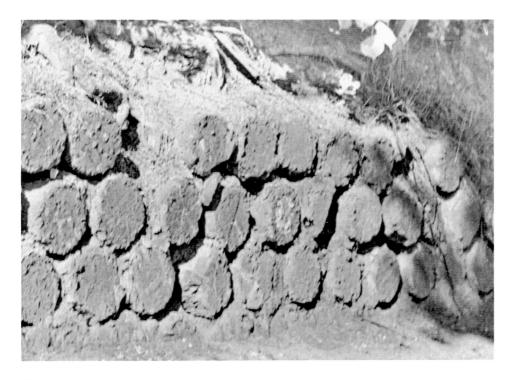

Church Farm

On the other side of Northfield Road is the Municipal Golf Course. Above is a photograph of phosphorous pots from Albright and Wilson. These pots form the wall at the entrance to the car park in Vicarage Road – the beginning of Steam Pot Lane – which ran across the farm to Northfield Road. The photograph below is taken from Quinton Road looking back towards the clubhouse, where the inset photograph was taken.

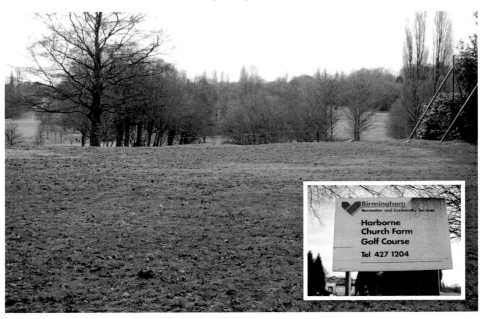

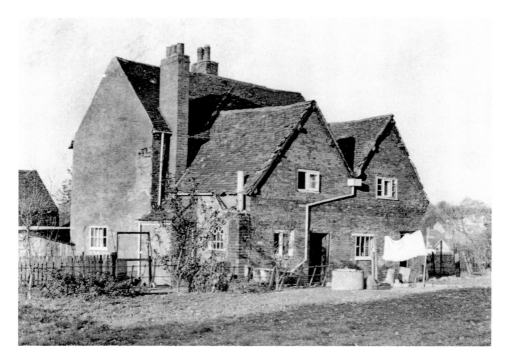

Weymoor Farm

Weymoor Farm stood almost on the corner of Northfield Road and Quinton Road, but is remembered in the name Weymoor Road, which runs parallel to it. Although the housing estate was built earlier, the farmhouse itself was only demolished in the 1960s and, until then, had flocks of hens. Quinton Road was originally scheduled to run through to Quinton but this never happened.

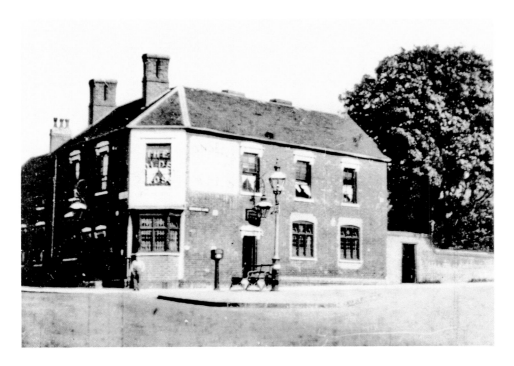

The Golden Cross

In 1841, the pub on this site was simply called the Cross. It occupied the corner of Metchley Lane, the border between Harborne and Edgbaston and, until 1891, the border of Staffordshire and Warwickshire. Now, sadly, even its replacement has been demolished as the road system has been altered and new buildings are under construction.

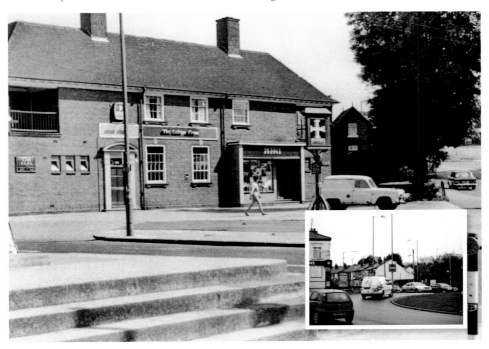

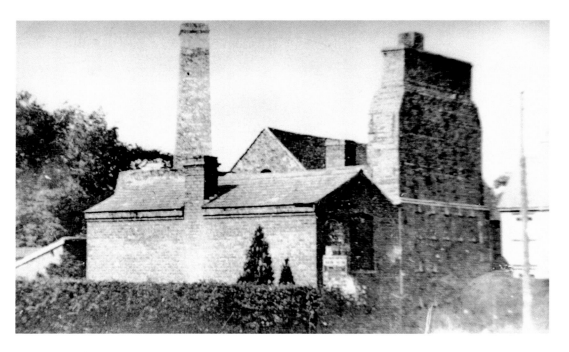

Harborne Mill

Harborne Mill was built on the streams that flowed from Bartley Green – the Stonehouse Brook and Welches Brook from Quinton. The mill was on the Harborne side of the boundary between Selly Oak in Worcestershire, and Harborne. This was a meeting point of the three counties; on the opposite side of the road was Warwickshire. Originally the mill was used for grinding corn but by 1767 it was involved in making metal parts. When the canal was created, a reservoir was built behind the mill.

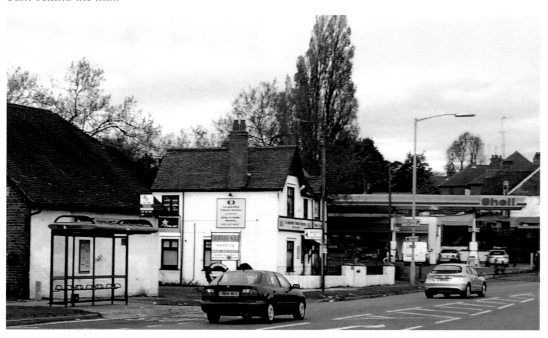

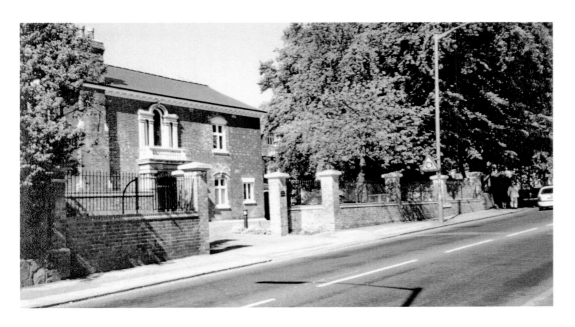

Dore House

Thomas Millington came to Harborne from Sheffield in the middle of the nineteenth century and used Harborne Mill to make steel plate. He built Dore House in Lordswood Road. It was named after his wife's birthplace – Dore, near Sheffield. The exterior of the house has changed little but it is now a residential care home.

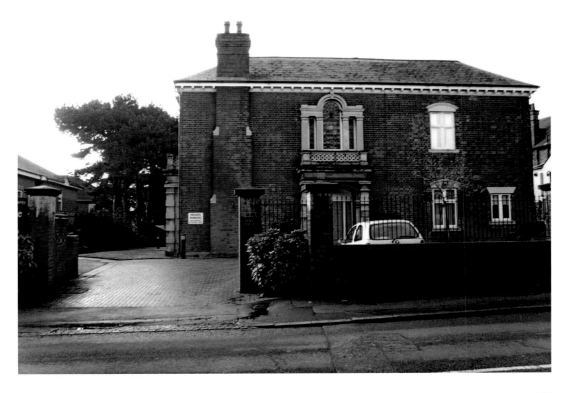

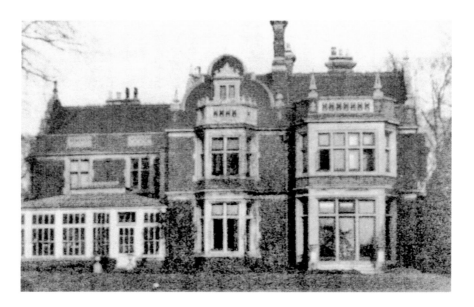

Metchley Grange

Walking up Metchley Lane in the 1920s there would have been parkland to the right. On the left, just before reaching Malins Road, was Metchley Grange, now demolished for a housing estate. This was the home of Sir Henry Wiggin, at one time Lord Mayor of Birmingham and an MP for East Staffordshire. He was a philanthropist and donated these cottages (below) off Margaret Road to elderly people. They were named after him. He too was a metal manufacturer.

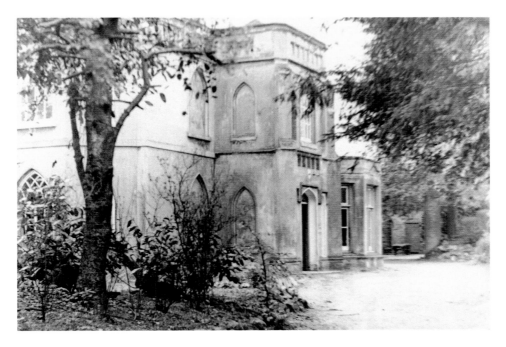

Metchley Abbey

Metchley Abbey was built in the early nineteenth century, on the site of a previous farm building, although there was never a genuine abbey here. Hezekiah Green lived in the old house and the Freemans in the new. E. A. Freeman was a well-known historian. Later it was the home of Charles Birch, Sir Graville Bantock, the composer, and lastly a branch of the Kenrick family. It is now part of Bromford Carinthia Housing, providing homes for the elderly.

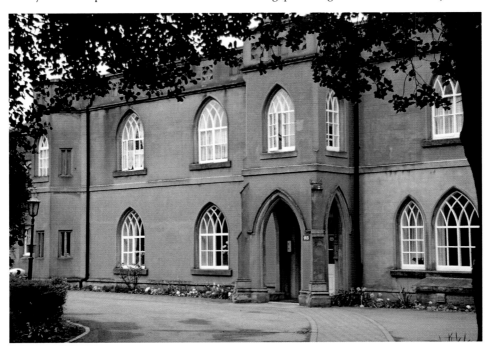

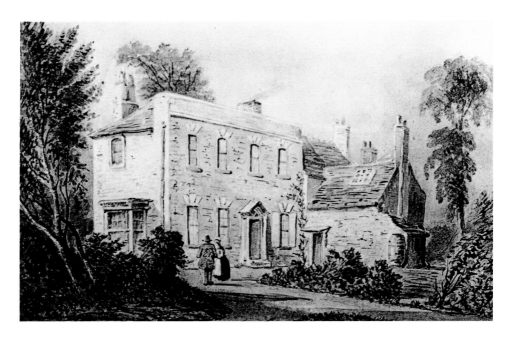

David Cox

Two pictures of the house in Greenfield Road where David Cox (1783–1859), the famous watercolour artist, lived from 1841 until his death. He is buried in Harborne churchyard. The house originally faced the High Street, then Heath Road and, in 1784, had the most windows in any of the Harborne houses. At some point it was remodelled to face Greenfield Road and is now split into five separate properties.

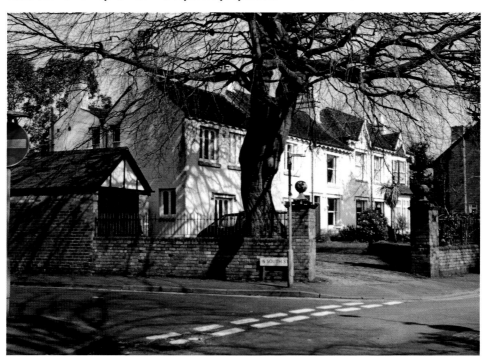

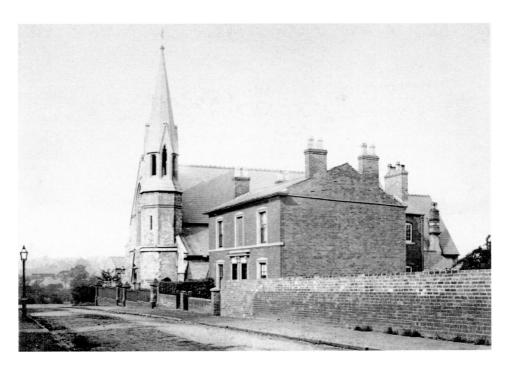

The Church of Saint John the Baptist, Harborne Heath

St John's (now on the High Street) was opened in 1858. Its first vicar built his house in Lordswood Road, where the medical centre is now. On Good Friday, 11 April 1941, a bomb landed on the church. Because it was on a timed fuse, it allowed the rescue some of the church's valuable items. The bomb exploded on Easter Sunday. Today, all that remains of this building is the far gate post.

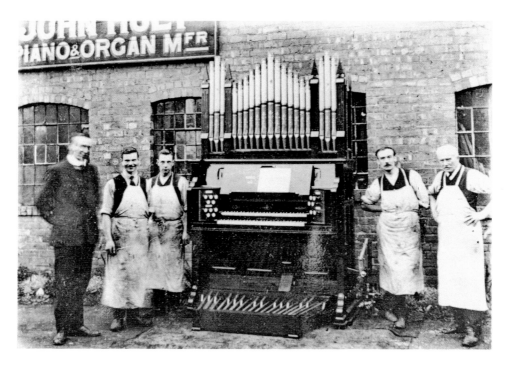

Clarence Mews

Clarence Road runs parallel to the High Street at the bottom of St John's Road and these buildings are at its junction with Station Road – the official address of the Pioneer Works. The organ factory moved here in 1899, building free-standing organs. Trade was adversely affected by the First World War and the premises were eventually updated and converted to housing.

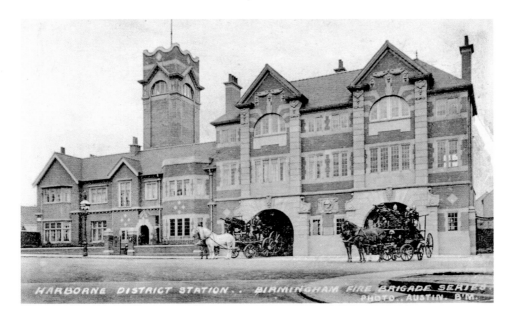

HARBORNE DISTRICT STATION .. BIRMINGHAM FIRE BRIGADE SERIES
PHOTO.. AUSTIN. B'M.

Fire

The original fire service was voluntary and operated from Serpentine Road. When this building first opened (1908) the vehicles were horse-drawn (photograph 1910) but were updated as modern vehicles became available. To the rear was accommodation for the firemen. The station moved to Woodgate and the building was converted into apartments.

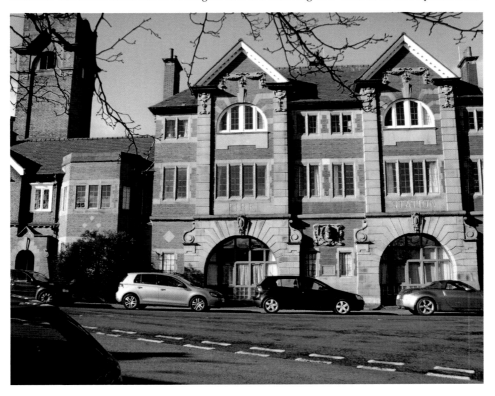

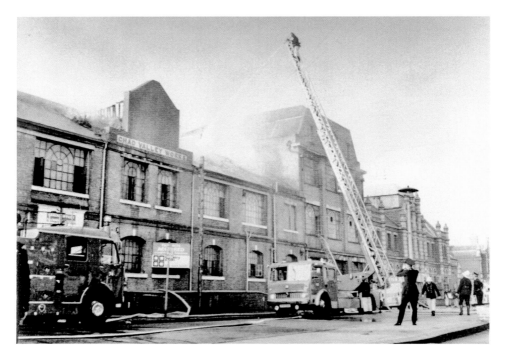

Chad Valley

In 1897, Johnson Brothers built a new factory in Rose Road, moving their printing and stationery works from the city centre. They diversified into games and jigsaws. In its heyday Chad Valley toys were famous, simply labelled 'Made in Harborne'. This fire at the factory occurred just before demolition. Beyond the factory can be seen the public works department. These flats have been built on the site in Chad Valley Close.

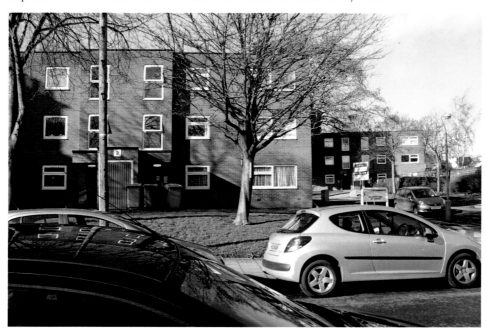

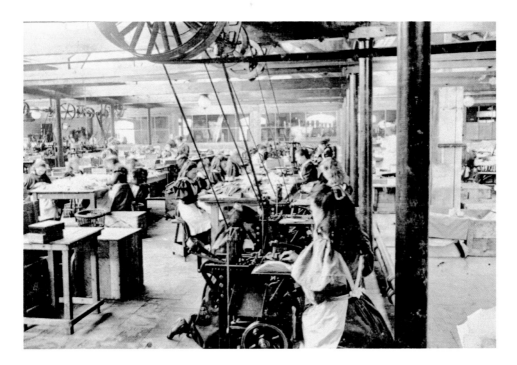

Printing and Toys

The printing side was male dominated and mainly done in the Harborne Institute. By the 1930s jigsaws and soft toys were being made. Stitching was done by the women. Like many other Birmingham factories, Chad Valley altered its production for the war effort. Below is a picture of part of the display in Harborne Library of a selection of the toys that were once made in the factory.

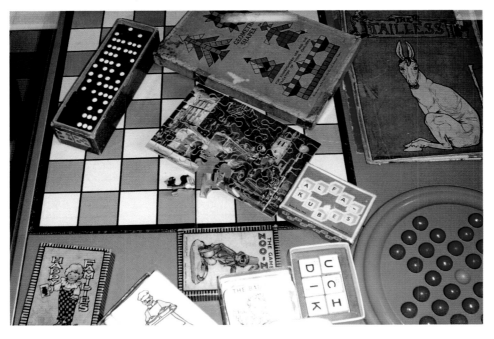

Law and Order

In the early days the nearest police station with cells was in West Bromwich. At one time there was a small lock up and village stocks at the top of War Lane. Harborne's earliest station with cells was on the High Street, accessed through the arched doorway. Today there is a purpose-built modern station in Rose Road where the public works department once stood.

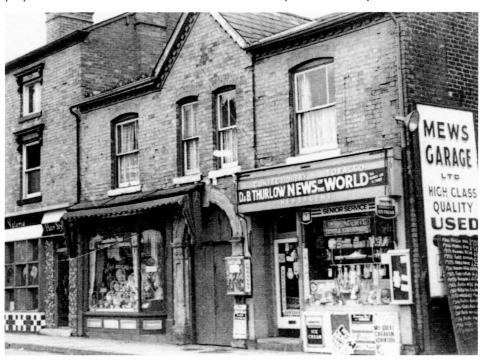

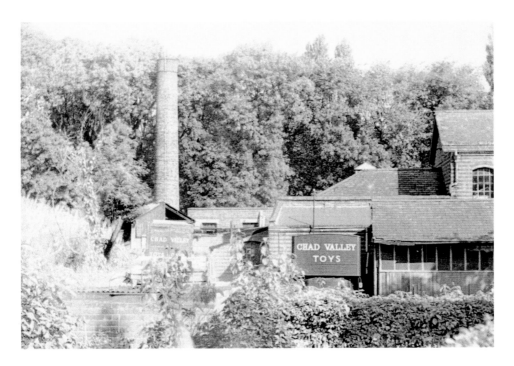

Mirror Laundry

This site next to the railway in Park Hill Road, originally a brickworks, was once occupied by the Mirror Laundry; continuing what had once been a major Harborne industry of the nineteenth century – laundering. The title 'laundress' appears in many of the censuses. In the 1950s Chad Valley took over the buildings. From the early 1990s it became the Weekin Works Business Park with fifteen individual units.

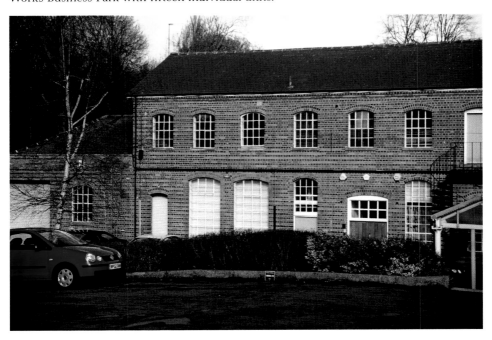

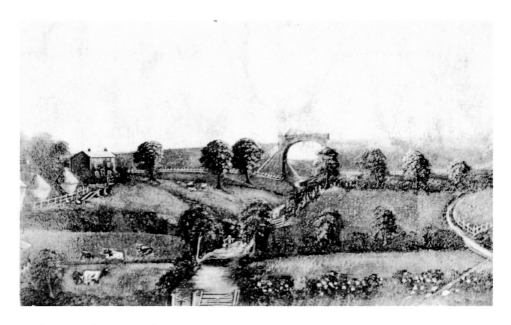

Harborne Styles Footpath

The note attached to the photograph states that it is the 'Old Harborne Stiles ... Wright's farm and the Old Pleck ... in 1878'. This causes some difficulty, as maps indicate that the farm was on the other side of the railway from the footpath, which ran from Lordswood Road, along the back of High Brow and Margaret Grove to Park Hill Road; however, it does show us rural Harborne, a contrast to today.

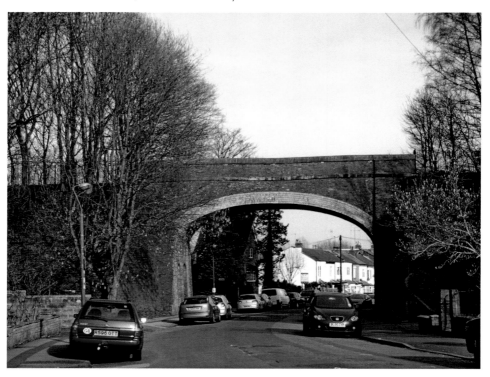

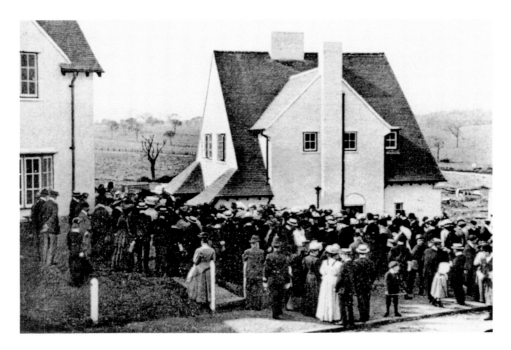

John Sutton Nettlefold and the Moor Pool Estate

Nettlefold became the first chairman of Birmingham's Town Planning Committee and began putting new ideas into practice when the building of the Moor Pool Estate began in 1908. 'It is fortunately becoming more and more recognised every day that open spaces are as necessary to the health of a town, as streets are to its traffic,' John Sutton Nettlefold, *Practical Housing* (1908, page 10).

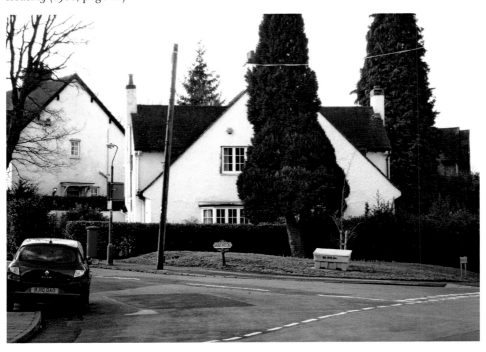

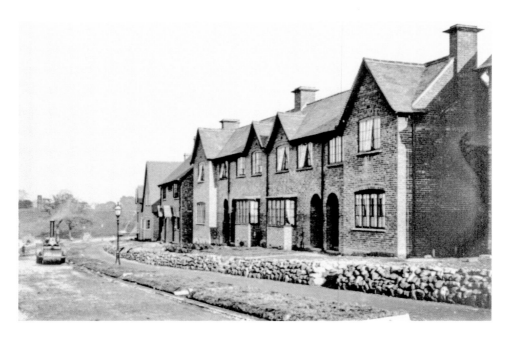

Moor Pool Avenue

Soon the open fields beyond those first houses would disappear under the new estate, but not completely. Behind the hedge on the left are tennis courts and allotments. As Nettlefold also said, 'The provision of allotments, as a counter-attraction to the public house, could also be arranged for, if only these things were thought of beforehand.' In the distance the Victorian railway bridge can just be seen.

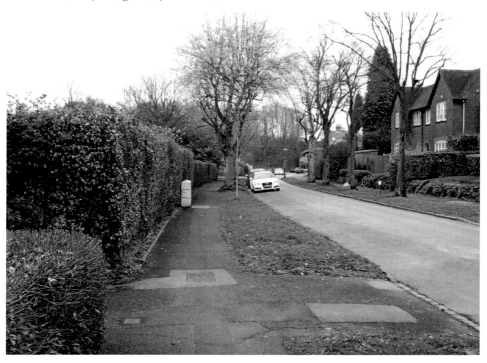

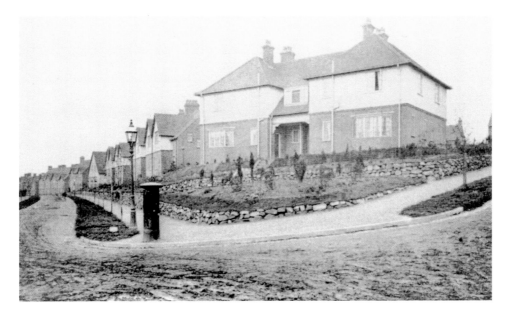

Moor Pool Avenue and Ravenhurst Road.
It would appear from the top photograph that the road surfacing could not keep pace with the house building. The roads on the estate were deliberately narrow to discourage motor cars – a mistake as there are few garages on the estate and parking is a problem. Two of the roads have been classed as one way to ease the traffic flow.

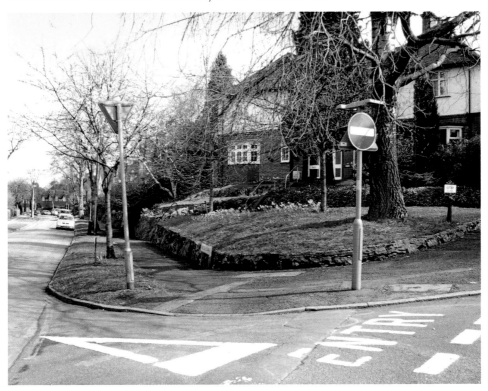

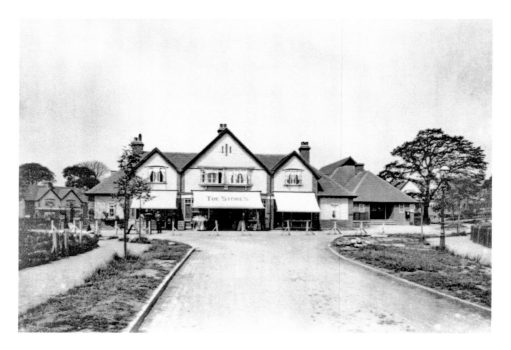

The Circle

This was certainly the hub, if not the actual centre, of the Estate. To the right is the hall, a venue for parties, wedding receptions, drama productions and meetings. Below the hall is a unique skittle ally. As stated by Steve Beauchampé in the *Birmingham Press*, it is 'possibly the last remaining dual skittle alley in Britain (and certainly the country's only surviving example of a round and flat alley combination)'. Upstairs at the rear is the snooker club.

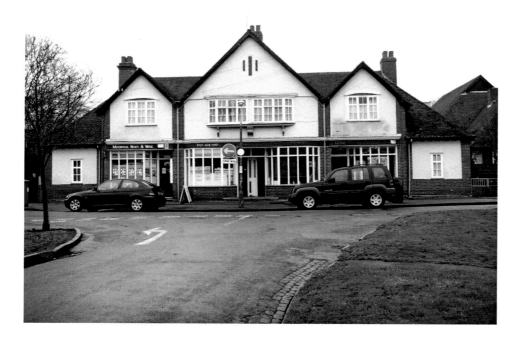

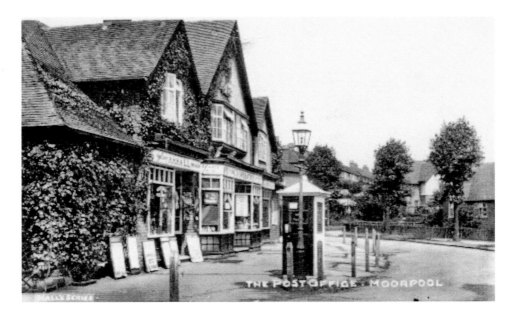

The Post Office

The shop on the left used to be the post office, until the government decided that there were too many, and this was one of the many that suffered. It also lost its public telephone box but has retained its EVIIR post box. Behind these shops were more tennis courts and offices where estate business was conducted, rents collected and repairs authorised. Not so now, as much is owned by Grainger PLC.

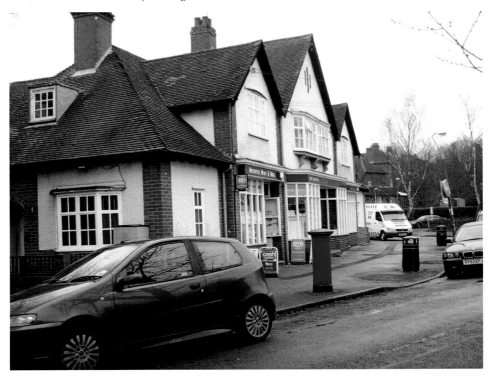

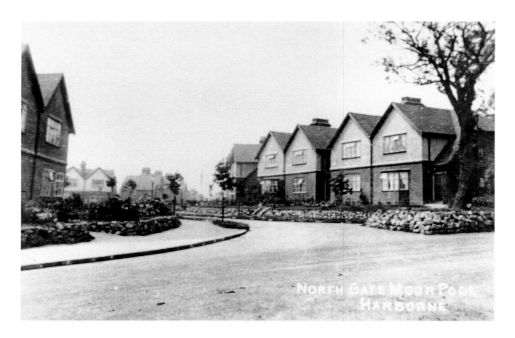

Building the Estate

Harborne Tenants Ltd was founded to promote the erection, co-operative ownership and administration of houses on the lands at Moor Pool. Houses were built and let at ordinary rents paying interest on the capital and dividing the surplus profits (by shares) amongst the tenants in proportion to the rents. This is the corner of North Gate, originally with an old tree standing on a triangular island, which was removed after the Second World War.

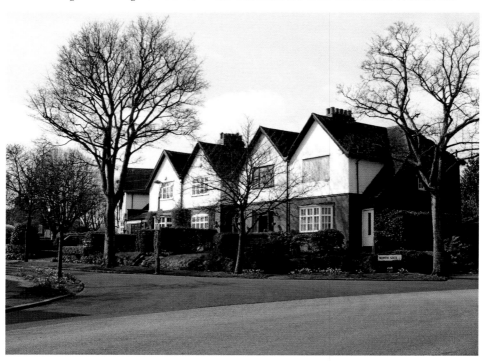

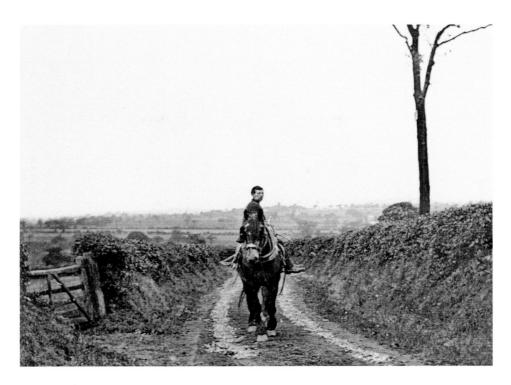

Moor Pool Lane

This is a view of Moor Pool Lane (Ravenhurst Road) in the latter half of the nineteenth century. Originally this was just a track running from the High Street to Upper and Lower Ravenhurst farms. Today there are houses and flats on both sides of the road except where the Moor Pool is situated. Invisible springs feed the pool, its waters ending in the North Sea via the River Rea, the Tame and the Trent.

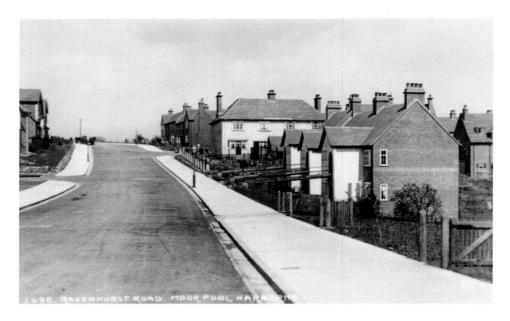

The Pool

On the left of the photograph is the Moor Pool from which the estate takes its name. On the right is a path down to garages and allotments, following the stream as it leaves the pool. At the top of Ravenhurst Road, newer houses built in the late 1920s and 1930s can be seen. Park Edge is the road on the left and only has houses on the side opposite the pool.

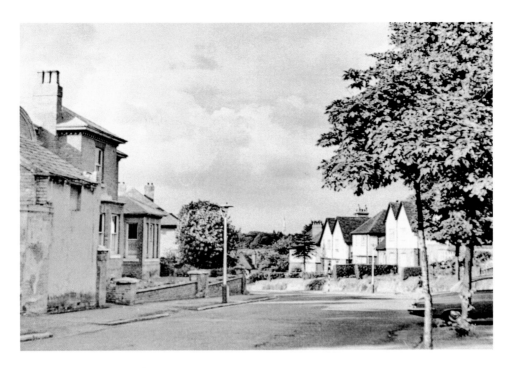

Leighton House School

This was one of several private schools in Harborne. There were church schools at St Mary's and St Peter's and the council school in Station Road and at the Clock Tower. The photograph is taken near the junction of Wentworth Road and Ravenhurst Road and the church in the distance is St Augustine's in Edgbaston.

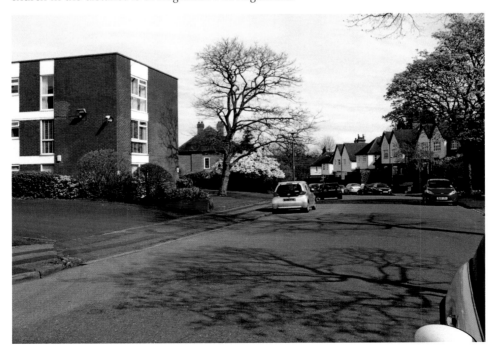

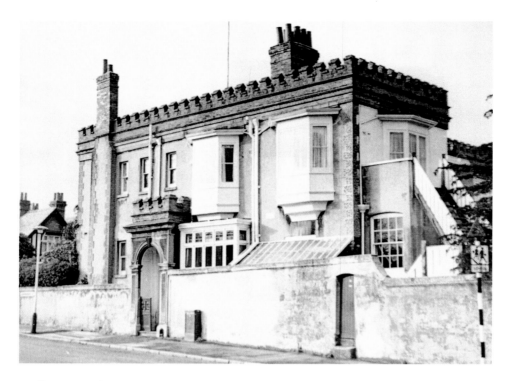

Wellington Lodge

This house on the corner of Ravenhurst Road was the home of William Cave-Browne-Cave, his wife Maria and their children. He was a grandson of Sir William Cave-Brown-Cave of Stretton Hall in Leicestershire, the ninth Baronet. His father Thomas, Sir William's third son, is buried in Harborne Churchyard. The 1881 census gives William's occupation as a corn merchant, while Maria is the farmer. By the 1970s the house had been demolished and two blocks of flats built.

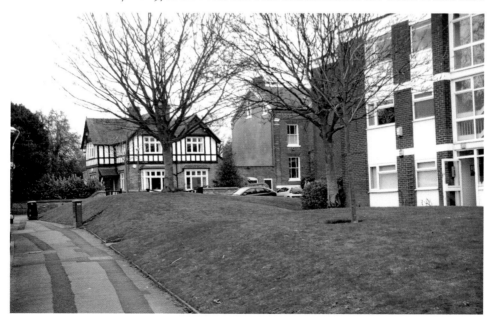

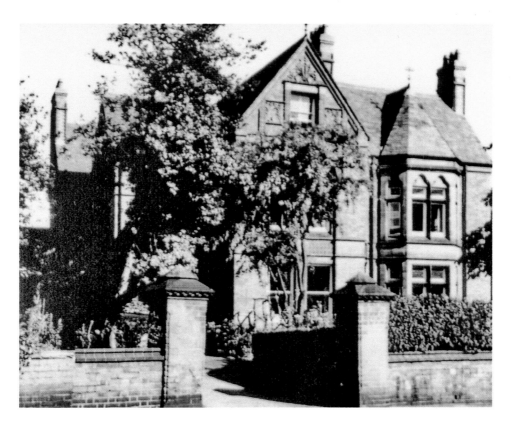

St John's Vicarage

The foundation stone for the vicarage in Wentworth Road was laid on 29 May 1885. Occupying an acre of land, it had four reception rooms and ten bedrooms, as well as three habitable basement rooms, rooms for church use, stables and a coach house. Outside there was a tennis court, clock golf, a vegetable garden, a rose garden and a chicken run. Today's vicarage, built in 1963, occupies the tennis court and the block of flats the remaining area.

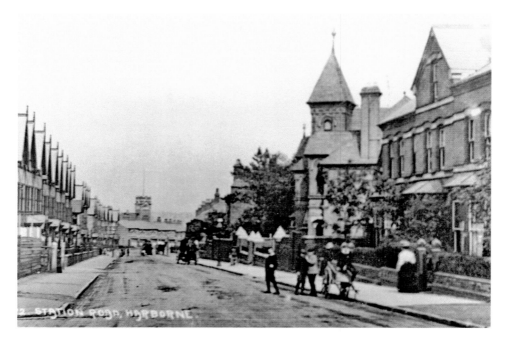

Station Road

Station Road is now a busy road, with humps to slow the traffic. Yet in many ways little has changed. Most of the buildings show little difference externally, although internally much has altered. The Institute has lost its tower and the skyline has a high-rise block of flats. The tower in the centre no longer has its mast but is still recognizable as part of the old fire station.

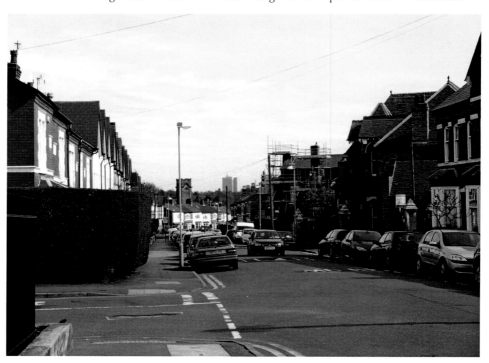

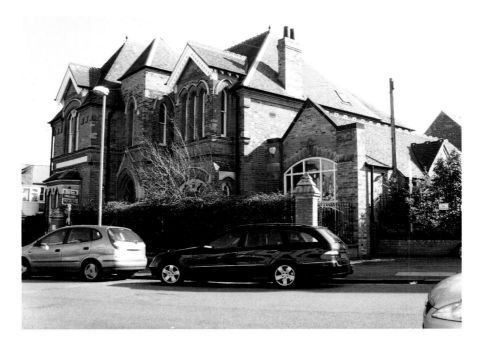

The Institute

The foundation stone for the Harborne & Edgbaston Institute 'was laid by Henry Irving Esq. August 12th 1878'. He was a Shakespearean actor. The money to build it was raised from the gentry and business community and it had two theatres and a library. The library moved to the Masonic building on the High Street, and the building was used by Chad Valley for printing after 1916. Following several other uses it is now apartments.

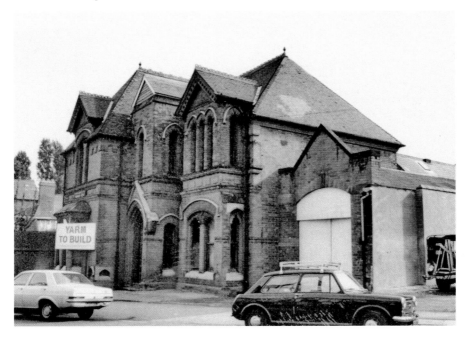

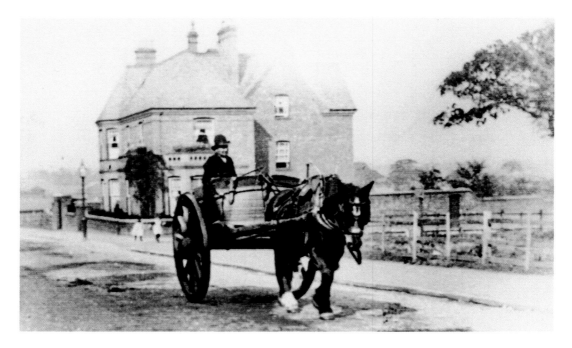

Health

In 1880, Dr Middleton set up a medical practice in York Street to provide a health service for the growing population of Harborne. He built a house and surgery in Albany Road in 1885, in what was quite a rural area. In 1922 it was bought by Dr Morton who used it until his death in 1969. It is still there, but some of its land has been used for housing, as has the land in Regent Road and Station Road.

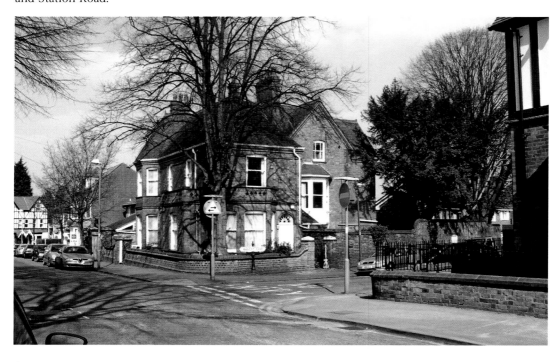

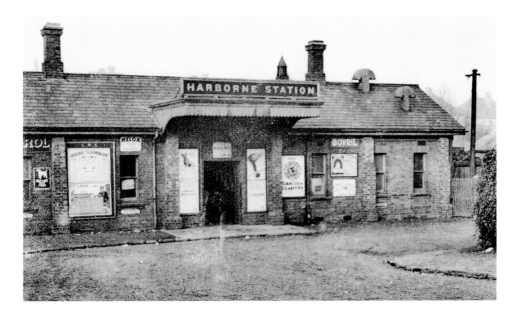

Harborne Railway

Opened in 1874, the railway was often referred to jokingly as 'The Harborne Flier' because it took so long to get from the city centre. There was no direct route as it did not have permission to go through Edgbaston and had to join the Wolverhampton line after passing through Summerfield Park and crossing the canal. In 1910 there were thirty trains a day. Frensham Way was built in the early 1970s.

The Last Train

The trains no longer run and Frensham Way and Chad Valley Close occupy the space. Passenger traffic had ceased in 1934, but goods trains continued to run until 1963. Occasional special passenger trains ran, but the last was in November 1963 and the line was officially closed. The Chad Valley works, seen in the distance, had a siding into the factory. In the 1980s the rest of the trackway from the bridge in Park Hill Road to Summefield Park became a walkway.

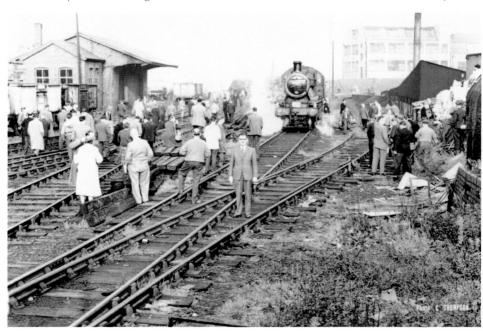

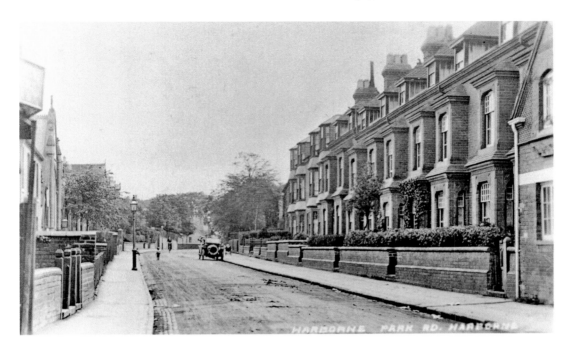

Harborne Park Road

This section of Harborne Park Road has changed little over the years, with the exception of the new Baptist church on the left. Beyond this view, the road becomes a dual carriageway built to take a tram from the King's Head on Hagley Road through to Selly Oak. By 1925, a new bus route rather than a tram was agreed and 7 April 1926 saw the 26 miles of the No. 11 Outer Circle completed.

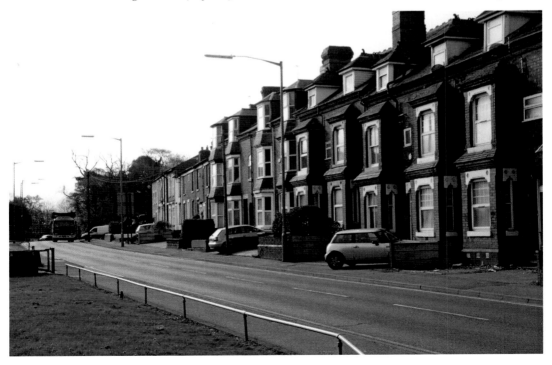

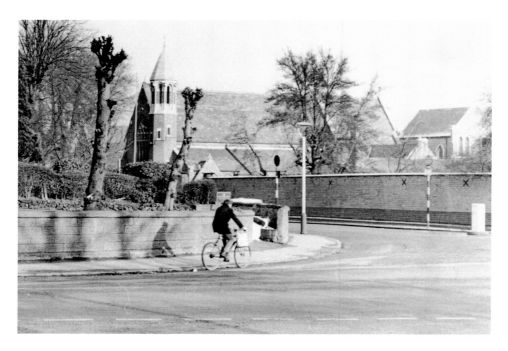

Saint Mary's Catholic Church

In 1877 St Mary's church was built and the congregation moved from the High Street. The original Lodge buildings were used as meeting rooms and accommodation. Harborne Lodge was situated at the entrance to 'The Park', home of Theodore Price who owned much of the land in Harborne. The church has been extended to the side of the original; new rooms have been added, and the day school is at the rear.

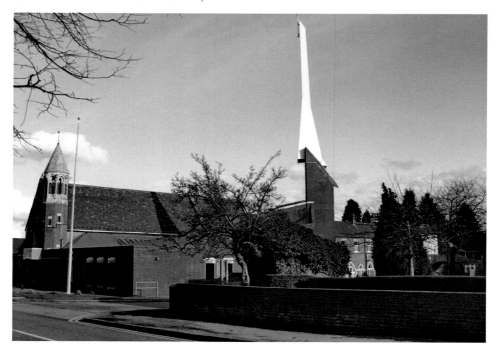

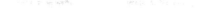

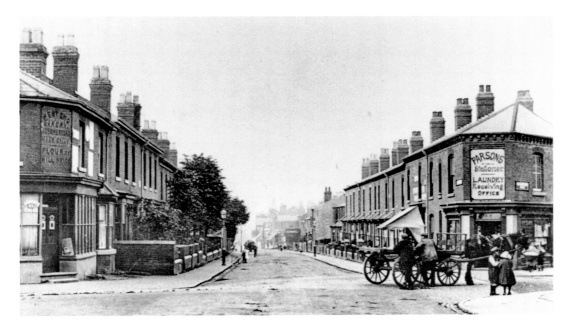

Vivian Road

These photographs are taken from near St Mary's church, looking down Vivian Road towards the junction. On the left, the bakery has been demolished and a block of apartments built along Greenfield Road to the High Street. On the right, Parsons has had several incarnations and is presently the Crossway, part of St John's church. The terraced houses in the distance were demolished and now form part of Waitrose car park.

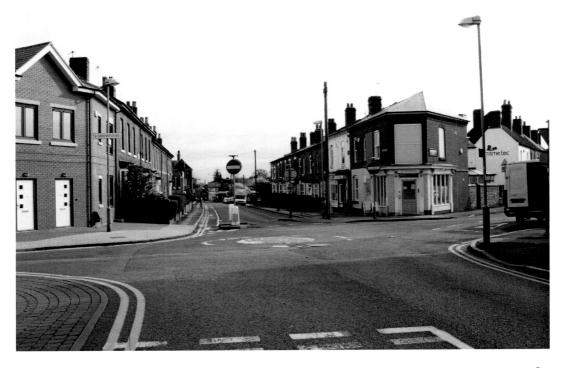

The New Inn

This is one of the few old inns of Harborne that remain without much alteration, but it was new once! The sign on the freshly painted pub has an incorrectly positioned bus staircase, and there is no evidence that any motor buses ever terminated here. However, horse buses definitely did, certainly by 1850. A. W. Reynolds had a daily service to the General Hospital in Steelhouse Lane, and Taylor's also ran a twice-hourly service to New Street.

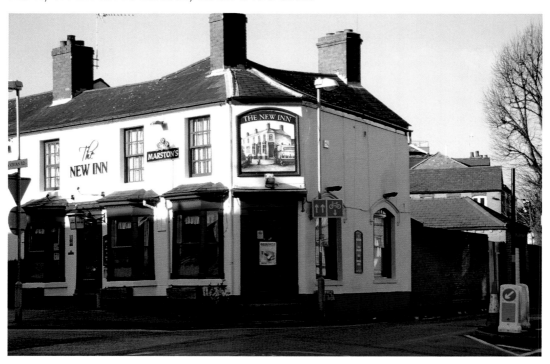

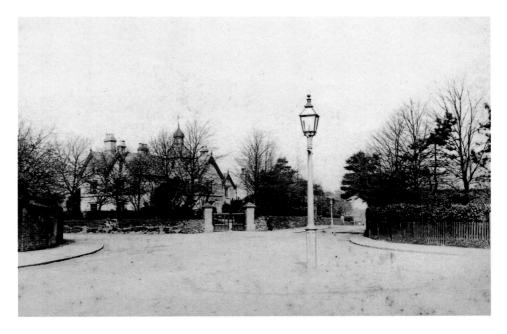

Clent House

Clent House, on the corner of St Peter's Road and Harborne Park Road, was demolished in 1955. The gateposts and trees are still there but there are some new houses in St Peter's Road. In 1881 Samuel Bennett, a retired coal master, lived here with his wife and nine children aged from 20 months to 20 years, and four servants. Not only has the house gone, but the road layout has also been altered.

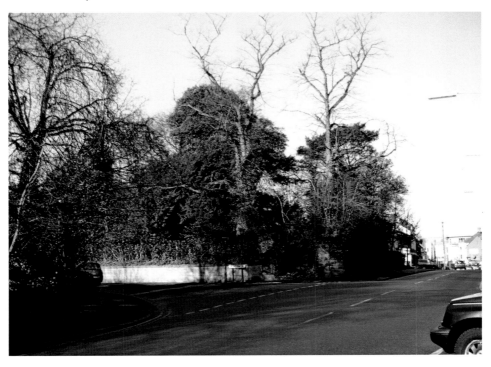

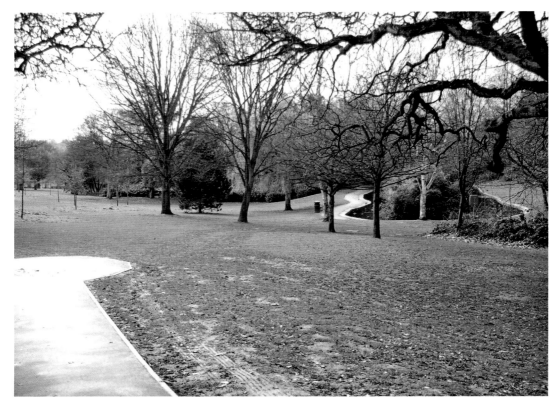

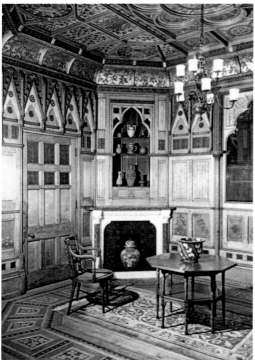

Grove Park

'The Grove' was once the home of Mary
Carless, whose daughter married Thomas
Attwood in 1806. He moved into the Grove
in 1823. At that time he was a banker
but was involved in the formation of the
Birmingham Political Union, a peaceful
campaign for reform. Following the Reform
Act of 1832, Attwood became one of the first
two Birmingham Members of Parliament.
When the Grove was demolished, this room,
known as the 'Harborne Room' was taken to
London and re-erected in the Victoria and
Albert Museum.

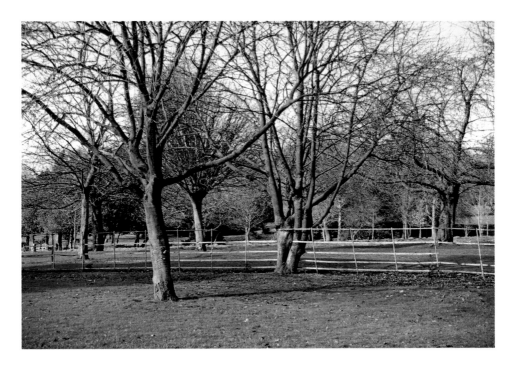

Grove Park

The last family to live at the Grove – demolished in 1963 – were the Kenricks, who gifted the parkland to the city council. A proposal to build on it was defeated. At one time there was an old people's home in Grove Lane, now replaced by the Kenrick Centre. Much of the old fencing can still be seen in the park. Jimmy Hicks was head coachman to the Kenricks for 50 years.

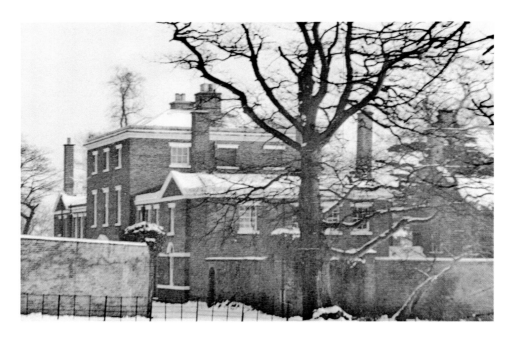

Bishop's Croft

Known as Harborne House, it was built (1780) by Thomas Green (Lord of the Manor in 1790), an ironmaster. Edward Cresswell and David Jones – other ironmasters – lived there later. Thomas Green had no sons. One daughter – Elizabeth – married George Simcox. The other – Ann – married Theodore Price. The house became Bishop's Croft in 1911, following the creation of the new Diocese of Birmingham in 1905. Later diocesan offices were built in the grounds facing onto Harborne Park Road.

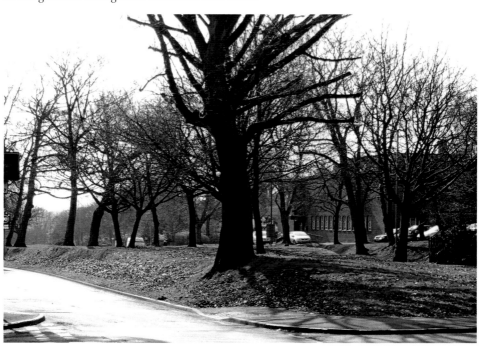

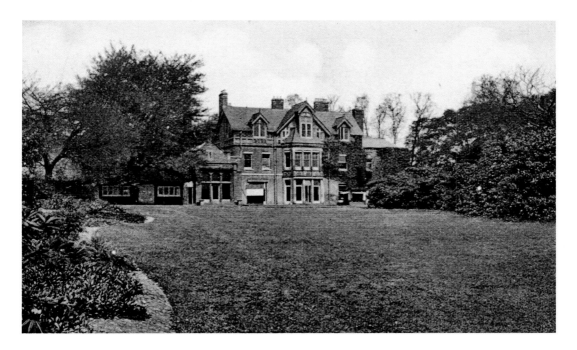

Harborne Hall

The Hall was built for George and Elizabeth Simcox, but she died leaving a son, Thomas Green Simcox, to inherit the title Lord of the Manor. It has been home to Charles Hart, Walter Chamberlain, Edward Nettlefold, Belgian refugees, a hospital, a boarding school, a conference centre, and now (2011) to pupils from Harborne Junior School whose building was destroyed by fire on 27 April. A fête was organied to raise money to help re-equip the school.

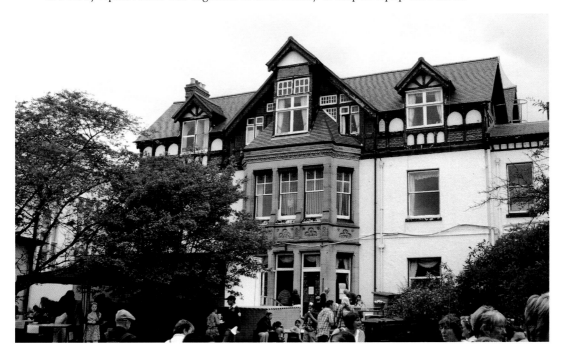

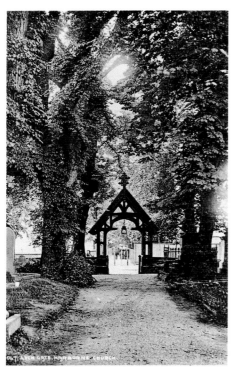

The Avenue

St Peter's churchyard has three lych-gates. One is the Hart gate near to Harborne Hall and Bishop's Croft. This second one leads to the Avenue, which goes through to Harborne Park Road. Harborne Cricket Club has played at the Old Church Avenue grounds since 1874. Walter Chamberlain is buried in the churchyard; as is Anne Vere Chamberlain, wife of Neville Chamberlain, Prime Minister (1937–40).

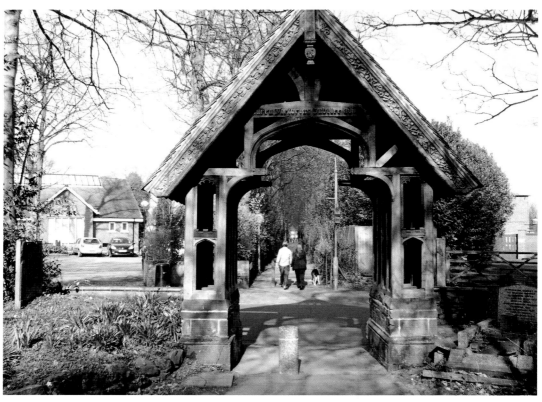

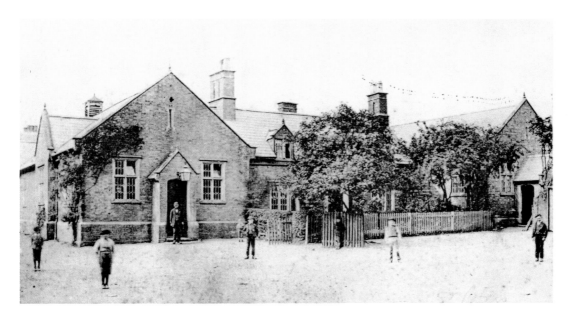

St Peter's School

In 1757, residents raised funds for a school to be built on land leased from Sir Thomas Birch where the old Police Station stood. It was known as the Free School. In 1837 the school was rebuilt on its present site and renamed the National School. There were two classrooms and a house for the School Master. It was enlarged in 1848, 1879, 1903 and 1912, becoming St Peter's Church of England school after the war.

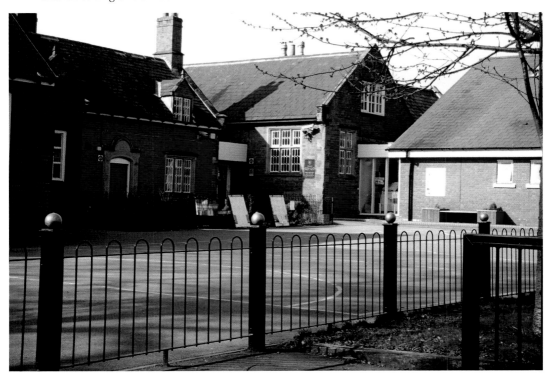

St Peter's Road

The cottage on the left-hand side of St Peter's Road was Harborne's first post office and the home of Samuel Dugmore. He was also the parish clerk, the registrar and the enumerator for the 1841 census. This third lych-gate of the churchyard was built in memory of Eliza Roberts, the vicar's wife, who ran the vicarage school for many years.

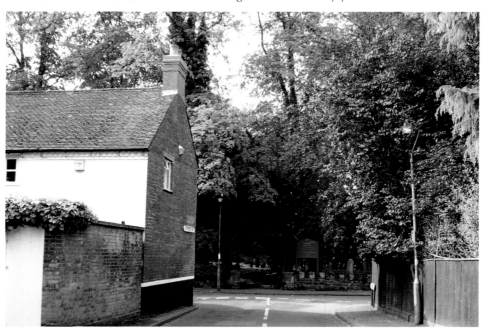

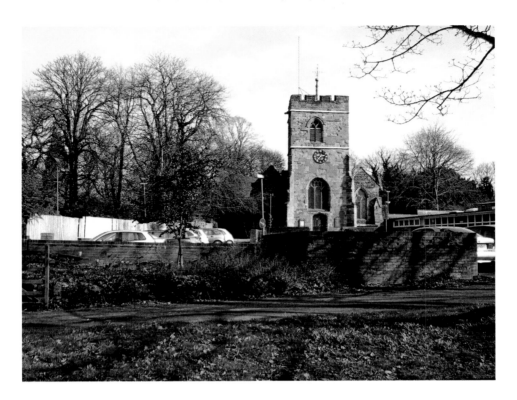

St Peter's Vicarage

A car park has replaced the old vicarage. To the right are the church hall, church office and the vicarage. The old vicarage, built in the 1840s, was also used as a private boarding school in the 1880s and 1890s. The field next to the vicarage is still used for activities by the community. Guides, Brownies and Rainbows renewed their promise here at 20:10 on 20/10 in 2010. St Peter's Guide unit is one of the oldest in the country.

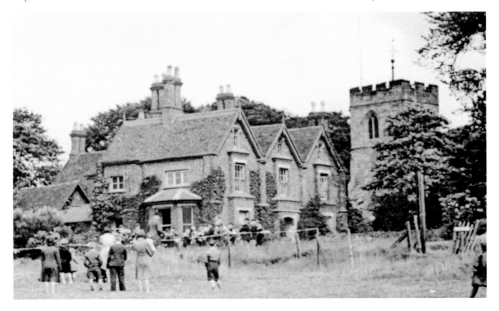

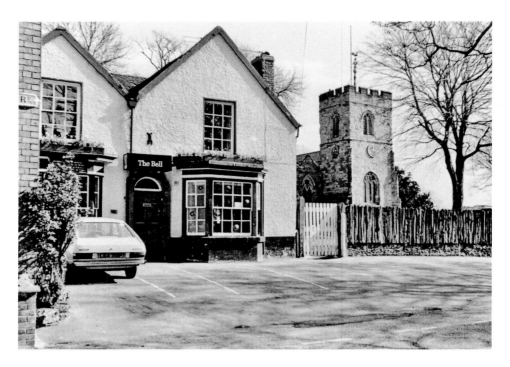

The Bell

Typical of many villages was the pub next to the church, although Harborne was not a typical village. The tower – the oldest part of the church – dates from the fourteenth century, but the rebuilding and remodelling of the rest have taken place both inside and out. Major rebuilding took place in 1827 and 1867. The Bell was an old farmhouse with parts dating back to the sixteenth, seventeenth and eighteenth centuries.

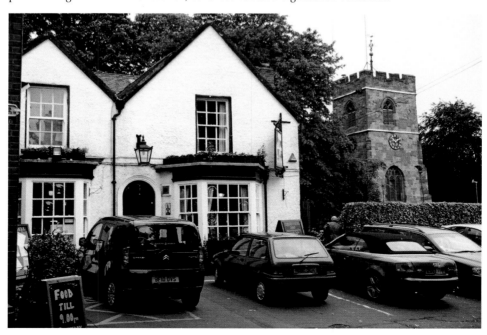